Move Closer

Move Closer

An Intimate Philosophy of Art

JOHN ARMSTRONG

Farrar, Straus and Giroux
NEW YORK

Farrar, Straus and Giroux
19 Union Square West, New York 10003

Copyright © 2000 by John Armstrong
All rights reserved
Distributed in Canada by Douglas & McIntyre Ltd.
Printed in Great Britain
First published in 2000 by Penguin, Great Britain
First published in the United States by Farrar, Straus and Giroux
First American edition, 2000

Library of Congress Cataloging-in-Publication Data

Armstrong, John, 1966–
 Move Closer: an intimate philosophy of art / John Armstrong.—1st ed.
 p. cm.
 ISBN 0–374–10596–0 (alk. paper)
 1. Art appreciation. I. Title.

N7477 .A75 2000
701'.17—dc21 00–055130

Contents

List of Illustrations

Affection

She goes to see the masterpiece as excitedly as if she were finishing a serial story or consulting a fortune-teller or waiting for her lover. But all she sees in the picture is a man sitting meditating by the window, in a room where there is not much light. She waits for a moment in case something more might appear – as in a boulevard transparency. And though hypocrisy may seal her lips, she says in her heart of hearts: 'Is that all there is to Rembrandt's *Philosopher*?'

Marcel Proust, Camille Saint-Saëns.

The arts have almost always enjoyed public honour – and perhaps have never been held in higher esteem than today: fine buildings are preserved for the nation and visited by millions; the greatest paintings are gathered in public galleries which are almost always crowded. The world's most beautiful cities are too popular; their charm is threatened by their fame. The prevailing sense of what to do with a work of art – when you are actually positioned in front of it – is correspondingly reverential. Respect for art is played out in the hushed tones we adopt, in our careful ear for the words of the tour-guide or nervous consultation of the guidebook. It is captured definitively in the scholarly and dignified air of art monographs. But what of our private, individual response to particular works of art – how does that match the public eulogy?

The promise that something is going to be wonderful (a promise implicit in the high reputation of art) may raise our hopes too high: to a degree unsuited to the kind of enjoyment actually on offer. As Proust indelicately points out, the pleasures art invites us to are subdued in comparison with many other excitements life offers. The child who is upset that Miffy 'the enormous rabbit' turns out to fit in a shoebox has not yet learned to take it for granted that 'enormous', in this case, means 'enormous for a rabbit'. When it comes to art we are often unsure what to expect – we are not very confident about the pitch and register of the excitement at stake – and so are prone to look a little wildly for a startling impact, for a rabbit the size of a sofa. This deflationary line does not entail that art promises no delights; it indicates only that if we approach with an impatient expectation of dramatic gratification we are open to disappointment. Recognition of this raises a new problem: what are the kinds of satisfaction which are available in the gallery? And what posture of attention do we need to adopt in order to enjoy them? The real problem is not 'Why do things go wrong?' But 'How can we get things to go better?' In pursuit of an answer to this more hopeful question – the question around which this book is structured – we might start by considering a happier art experience.

On a rainy afternoon, during an out-of-season trip to a provincial French town, you wander into the municipal gallery. Finding yourself in a room of paintings by people you have never heard of, you set yourself to pick out the three which appeal most – the three which you would take home to hang in the sitting room, if only the guard would doze off for a couple of minutes. In this situation it is often easier to enjoy pictures – as it can be sitting in the café looking at the postcards bought in the gallery or at home on the sofa flicking through the glossy illustrations of an exhibi-

tion catalogue. Free from pressure to respond, we can linger or ignore without worrying whether we are doing the right thing. And in these more benign conditions our eye can settle and responses flourish.

The idea of having a favourite picture brings into view the fact, generally kept rather quiet in the discussion of masterpieces, that we are sometimes tempted to speak of works of art in terms usually reserved for relations with people – using the language of affection. Exaggeration ('I adore chocolate éclairs') aside, this way of speaking is reserved for our more serious, and potentially rewarding, attachments. And to speak in these warm terms about a painting or a building is to propose a high privilege for art: like certain people, and unlike confectionary, art can enter importantly into our lives.

It is easy to feel about affection as Augustine famously did about time: you know what it is, up to the moment someone asks you to describe it. However, two characteristics seem crucial when it is used in connection with art: magnetism – the force of fascination – and intimacy – the sense of being engaged in an especially personal and private way. And to speak of affection for a work of art is to make the salutary reminder that paintings and buildings can provoke intimate fascination. Salutary because the language of art-historical scholarship and the often grand public setting of art can encourage an impersonal attitude.

Art-disappointment reveals a gap between personal response and public status. Under pressure, out of a desire to behave well, we may disregard our own unmoved state and endorse the general enthusiasm – even to the point of half-convincing ourselves that we must be having a rather special time. But this still leaves an embarrassing distance between the high repute of the work and our own rather cool reaction.

This gap is troubling in the philosophical discussion of art not just because it is a pity if we don't have a better time in the gallery but also because the stature of a work of art is intimately tied to the quality of experience it offers the spectator. What makes a three-star painting or building (to adopt the useful terminology of the Michelin Guide) is, in the end, that it offers the visitor a three-star experience. The greater a work of art, the more valuable the experience it invites us to. While often this value is cashed in terms of enjoyment, it can (of course) be that we sometimes place a premium on experiences which are disturbing or distressing. Contemplation of Michelangelo's *Last Judgment* or Picasso's *Guernica* can hardly be classed as wholly pleasurable – unless we ignore the extremely sombre view of life in one, or the rendition of agony in the other. But to ignore these aspects would be to avoid something central to each work. However, even in cases like these, it is apparent that we prize the experience of contemplating the works.

It is liberating and humane to think that the *Mona Lisa* and Rembrandt's *Philosopher* are great art because they invite us to an attractive and interesting experience – because of the affection they can excite – rather than because they accord with some impersonal criterion like financial value, age or historical influence. Yet, as Proust's unfortunate character illustrates, the magnetism and intimacy which characterize the real enjoyment of a work of art are not fostered – and may actually be undermined – by the true but blank assertion that the work is a masterpiece.

Talk of affection and the quality of experience focuses our attention on what is going on inside the spectator who stands gingerly before a celebrated work. However crowded the gallery, an encounter with a work of art is always something we pursue alone – no one else can make the work matter to us. When con-

templating a work of art one of the key questions ought to be: 'What is this to me?' This is asked not in the sceptical tone it sometimes takes, implying 'And I think it's pretty irrelevant to me really,' but rather in the tone of genuine inquiry, implying that one might come to discover how the object does matter in a personal sense, and that one might come to love it. But it is often hard to see how paintings and buildings could be personally important, not least because they are often presented in terms which make no reference to the personal. And they themselves are, often enough, products of eras and attitudes whose personal pertinence can be hard to grasp.

The problem is exacerbated by the fact that the word 'important' is used in two rather different ways. A curator or art-historian might say a work is 'important' because it is historically significant, because it reveals something curious about the age in which it was produced, or because it influenced subsequent artists. The visitor to the gallery or celebrated building may, however, admit that these objects are important within the history of art (the history of how people have expressed their concerns and attachments and communicated their vision of the world and of ideas) – they may readily admit all this without granting the crucial addendum: 'And they are important to me.'

One way in which the *Mona Lisa* is important in the history of art is that it is an early and especially accomplished example of the use of *sfumato*: the use of shading to suggest contour. When we look at Mona Lisa's chin we cannot pin-point any line which marks its edge – as we would have seen in the more linear paintings which were the norm in this period. It was this technique which also allowed Leonardo to generate the impression of the contours of her mouth and eyes shading off imperceptibly. This technique was a major innovation in painting – and important in

the purely historical sense that subsequent painters made extensive use of it. But this does not show that the technique itself had any special human import – more specifically, a present importance for me. The invention of the top hat made an impact on men's fashion – in that lots of people wore them – and in that sense was important within the history of costume, but that does not show that the top hat was a spiritual achievement or that it has any intimate value for the modern dresser. To take an artistic case: the dramatic innovation of Duchamp, who was the first to exhibit, unmodified and as works of art, mass-produced objects. This was historically important in that many subsequent people cited Duchamp as an inspiration. But whether what Duchamp did was humanly important, or more narrowly, important to me, is a question not resolved by citing historical impact. The question of importance to the individual spectator is one which needs to be pursued along other lines.

Emphasis on the individual and personal aspect of engagement with art sometimes distresses philosophers. A primary reason for this is the conviction that such an emphasis amounts to the view that the value of a work of art is to be understood purely subjectively, that is, that the work is as good or as bad as any particular spectator happens to think it is. This is an extreme form of relativism. This is an unacceptable consequence because it entails that there is no truth of the matter when we come to questions such as: 'Is the work of Vermeer greater than that of Bingo the painting chimp?' or 'Are the buildings of Palladio superior to those of Barratt housing?' But since these questions do have true answers, it cannot be that the merit of a work of art is purely subjective or wholly relative to the likes and dislikes of individual spectators.

But to have settled this point is not, perhaps, to have settled

the significant issue. For it is not simply the objective merit of a work which is of interest to us. After all, no one person can have an equal appreciation of all great works, there will always be certain kinds of art, certain styles and certain individual objects which have a deeper resonance for any particular spectator. The lesser-known German painter Menzel (plate 1) is fairly modest in his artistic achievement; nevertheless, his work has a particular allure for me – in some of his pictures, particularly in his domestic interiors, he catches notes of warmth and serenity which have a special charm. On the other hand, there are painters whose greatness I do not doubt but whose work holds little personal appeal. More importantly, even if an objective order of merit is conceded, it still remains that our access to the merits of a work is through our personal engagement with it. It benefits me little to believe (correctly) that the *Mona Lisa* is a masterpiece if, when standing before it, I can see nothing of interest or charm in it, if I have no access to its greatness. Even though my belief is true, it is a hollow, pointless truth.

Some philosophers reject the personal approach to art because they are frustrated by the easy way this is sometimes used to close down discussion ('Bingo is better than Vermeer and I won't listen to another word on the subject.'). Emphasis on subjectivity does not leave room for an external point of leverage from which to prove to another person that their opinion is mistaken: intransigence cannot be overcome. This is galling.

But the fear is exaggerated. Emphasis on subjectivity does occasionally encourage intransigence ('It's my opinion and I won't budge.'), but this unlovely quality is in fact foreign to most people's engagement with art. Precisely, we want to cultivate and develop our personal response, we want to deepen and refine our engagement with painting and architecture. First appearances

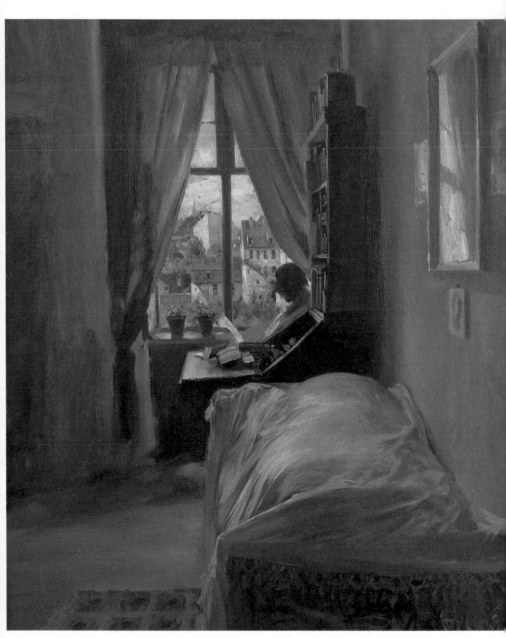

1. Menzel, *The Artist's Bedroom*. A charming room, but is Menzel an important painter?

notwithstanding, emphasis upon the personal and individual response need not signal a retreat into a merely relativist conception of artistic value. For the individual response does not in general rest serenely content, it aspires to be more perceptive and more richly involved with the individual works we are drawn to: it is anything but intransigent. Although we want to have our own response, we are not under a maniacal conviction that our own response is perfect. We often have, on the contrary, a presentiment that there is more to be drawn out of a work than we are presently able to grasp.

Even if a personal response cannot simply be evaluated as right or wrong, it can be perceptive rather than dull, engaged rather than listless, and experienced as a matter of importance rather than of indifference. We want to enhance our own response, but we are unsure how to develop confidence in our engagement with art.

Two questions face us: What do I have to do – beyond just staring – to get the most out of looking at works of art (to avoid the kind of disappointment we started with)? And: What is the importance of any particular work to me, how might it matter in my life, how might I feel affection for it?

The Way
of Information

The faithful follower of the Michelin Guide to Italy is likely to
end up standing in the Via XX Settembre in Rome in front of the
three-star façade of Santa Susanna (plate 2) – and a little puzzled.
Although others get praised for their interiors, frescos or statu-
ary, this is the only church in Rome which gets highest honours
specifically for its exterior. It is certainly nice, but – after all –
it doesn't look so very different from many other churches in
the city. The lower wings mounting with a scroll-like flourish to
the higher triangular pediment, the clutch of pilasters and the
big wooden door make up a familiar Roman type. S. Susanna
might strike one as not very dissimilar to, say, Santa Caterina de'
Funari (plate 3), which does not even make it on to the list of
churches most worth visiting. Is this an aberration of the guide-
book or is there something we are failing to notice? Perhaps – in
pursuit of a three-star experience and a more intimate grasp of
the artistic interest of the building – it is time to seek further
information.

An appeal to information is usually our first resort when con-
sidering what we need to do in order to engage more fruitfully
with a work of art: our first assumption that we need to find out
more about it. This appeal is encouraged by the fact that knowl-
edge usually is a necessary component of appreciation: artists

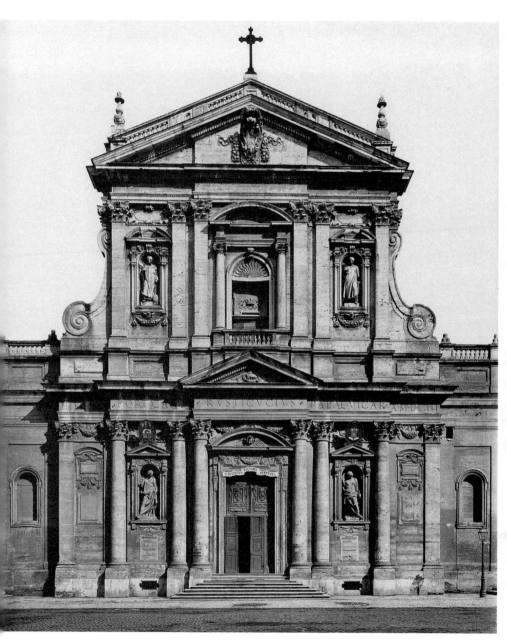

2. Santa Susanna, Rome. The façade gets three stars, but what is so special about it?

have generally supposed that their audiences would be armed with contextual knowledge – especially such as could be taken for granted by the audience of the day; but frequently we have to acquire deliberately what they knew subliminally. We now have to supply contextual knowledge in a self-conscious and laborious way. In addition, to understand the achievement of the artist, we need to be aware of what else was going on at the time: perhaps the church we are looking at was innovative, or was it a return to an earlier prototype?

Although well motivated, the appeal to information is not simply a reflection of its utility in promoting appreciation. There are (it seems) deep psychological roots to the allure of information – and in the light of these we may be drawn to overestimate the importance of knowing lots of facts.

Information is respectable. When it feels risky to advance a personal opinion – or when we have no opinion – it is reassuring to cite facts. It can seem too exposing, or potentially embarrassing, to assert a passionate attachment to, or repulsion from, a work of art. The surest way to impress others (and oneself) in the gallery or on the Corso is to recite names and dates, schools and influences. The celebrated errors of judgement (mocking the Impressionists, not buying Van Gogh's pictures when they could be had by the dozen, the forged Vermeers and misattributed Rembrandts) which make the history of art so picturesque create a climate of anxiety in which the expression of personal taste may leave one looking like a fool. The dispassion of fact is a natural refuge.

Unsure whether to like or dislike the façade, we can take comfort in knowing that it was built by Carlo Maderna, and knowing the difference between a Corinthian column (leaf motif at the top) and an Ionic (ram's horn scroll), or that the great German

art-historian Heinrich Wölfflin used this as a central example in his study of the development of Baroque architecture.

Masochistic glamour attaches to the difficulty with which information is acquired: it introduces the tinge of pain which, we feel, must accompany any worthwhile educational experience. This effort is prestigiously in the air as we reel off what we have memorized: that the façade was constructed at the very start of the seventeenth century (main fabric of the building is a little older); that the architect, Maderna, was later responsible for the revisions of Michelangelo's designs for St Peter's; that a vast amount of church building took place in Rome around this time – an aspect of the renewed clerical vigour of the Counter-Reformation.

The CV approach to getting to know something: it is curious that, when trying to get on with a person, we know that it is not always the most direct questions which encourage interesting conversation. The sort of information which is contained in someone's CV undoubtedly tells us something about them, but a conversation which restricted itself to CV-like topics would leave us feeling we hadn't come to know the person intimately.

Yet, feeling slightly nervous with a stranger, it is not too surprising if we fall back on unimaginative questions. Reflecting the fact that we don't have much sense of what it is we are looking for, our questions might be somewhat random – and this happens with works of art too. Asking a picture 'How much do you cost?', 'When were you painted?' and 'Who commissioned you?' seeks answers which might ultimately be important, but like inquiry into a person's age or income, they might not be the best place to start. We fire off the major questions but our initial concern ('Who are you really?') remains frustrated, even as we accumulate our dossier of apparently big facts.

Secret causes take precedence over what is available to the eye: in scientific and technological explanation – the most impressive kinds of explanation we have – this is the rule. There is little point in looking at a microwave oven to figure out how it works: how it looks is irrelevant. We need to know a great deal about electricity and sound waves before we can get started. Only then can we grasp why plugging it into the wall-socket should lead to a quickly cooked chicken. In other words, it is highly inconspicuous things which are most telling when it comes to understanding how the oven works.

We are primed to appeal to information when confronted by anything confusing – and we carry this readiness with us into our engagement with art. It is only natural, then, that we tend to look at the notices and consult guidebooks before looking at the works themselves. It is only natural that we feel we are getting more serious if our attention is drawn to unobtrusive things about the work and to arcane facts. And by contrast we tend to feel that we are being comparatively superficial if we concern ourselves primarily with features of the work which anyone can see.

Investigation of our love affair with facts does not cast doubt on the solid importance of information when it comes to understanding a work of art; it does, however, hint that the style of our approach might determine how interesting a time we have.

Being preoccupied, for example, with when something was made or who the designer or artist was can be a way of avoiding a more personal relationship with the object. External considerations can be so absorbing that they draw our attention away from the very thing which they are supposed to serve – we end up knowing about the picture or building, but not knowing it. Above all, information does not foster affection.

It is in contrast to these substitutions that giving oneself up to the visual character of the work and revelling in a personal response become attractive options. We can find the façade beautiful – we can enjoy its proportions, the colour and texture of worn and stained stone – without knowing when it was built. The capacity to let oneself go visually can be inhibited by a cautious waiting after the facts; as if we somehow don't have the right to like the building until we know more about it – until we receive the permission which the official character of information subtly grants. Our well-intentioned devotion to what is inconspicuous – to what has to be learned from books and archives – can lead us to neglect the conspicuous, surface charms of the building; we underestimate them because we have a prior, though misplaced, conviction that the significance of the work must lie elsewhere.

However, the exclusive alternatives that seem to be at work here – *either* extraneous knowledge with impoverished visual engagement *or* keen personal sensitivity pursued in ignorance – are rather primitive. Psychologically, the opposition is often real enough: the pursuit of information can forestall personal response. But 'can' is not 'must'. Perhaps we can have both. One opportunity for harmonious pulling together (rather than mutual inhibition) lies in the capacity information has to change and guide – in short to develop – the way we see.

Knowing that the façade was built at the beginning of the seventeenth century and that the architect was Carlo Maderna probably does not do much, in itself, to guide perception. That depends upon our being able to use those facts to bring our perception into contact with a web of comparisons and trends. That is, there is a wider network of information (either in our heads or in a more expansive guidebook) of which 'Maderna 1603' is a maximally concentrated precipitate.

We may know that at the time this façade was constructed there was a movement in Roman architecture (a movement in which Maderna was a leading figure) towards heavier and simpler forms. With this in mind our perceptions may be sharpened – we might become more sensitive when comparing Maderna's building with the façade of S. Caterina (plate 3) which was erected almost forty years before under the direction of Giacomo della Porta. We might notice that there is greater central emphasis in the later building; in S. Caterina, at ground level, all of the pilasters have equal emphasis, while in S. Susanna there is a rippling development towards the centre – pilasters give way to bolder half-columns and there is a doubling just by the door to underscore the point, while the whole central portion of the building takes two slight, but significant, steps forward.

Thinking about the door, at S. Susanna we notice that the rounded moulding which covers the portal is itself contained under a larger triangular pediment and that this latter pushes up into the next level. S. Caterina now looks particularly placid with the division between its two storey entirely unbroken. The later church is not only more massive but also more dynamic – it has momentum; to an eye thus sensitized the design exhibits great energy. We have come to appreciate this more keenly by seeing it in comparison with an earlier church in a related style and setting our perception within a framework of expectations. And we have been set on to this track by knowing something about the period in which it was built.

In describing how extraneous knowledge can help us perceive an object more acutely and engage with it visually with greater confidence we have not been concerned with isolated facts. It is not the bald statement that the front of the church was built in 1603 which has helped us, but rather the network of concerns to which

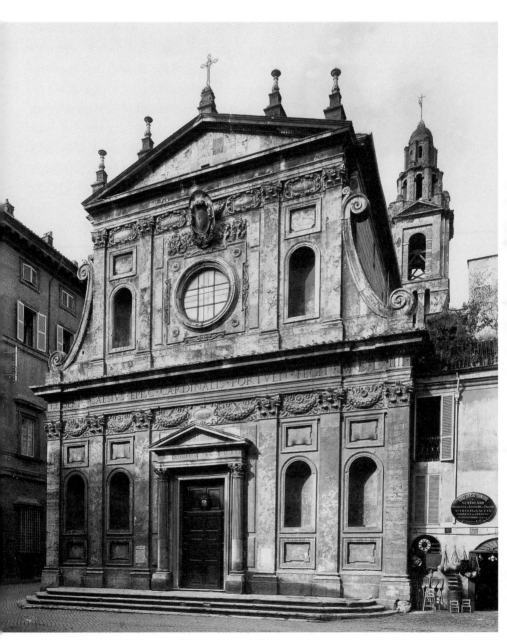

3. Santa Caterina de' Funari, Rome. The art of comparison: we see
the lightness and repose of this building when we compare it with the
previous picture of Santa Susanna.

that particular fact leads. Someone who knew nothing else about Roman architecture of the sixteenth and seventeenth centuries would not be helped simply by being given a date to contemplate.

On reflection, information often functions as a digest, or repository, of generalizations and reflections which are themselves originally visual. The background knowledge which the date taps into is supplied, in my own case, by reading Heinrich Wölfflin's pioneering study of the development of Baroque architecture. Wölfflin identified a shift from a light, static and linear style to a more massive and dynamic way of building which took place towards the end of the sixteenth century in Rome; and it is into some such pattern as this that knowledge of dates leads.

But Wölfflin himself derived his understanding from the hours he spent looking at a large number of buildings, noting that some struck him as static, others as dynamic, some as light, others as massive. He codified his experience in an account of historical development, and it became 'information'. When this information is dissolved in our perception – making us sensitive to the visual character of the architecture – the power of Wölfflin's original visual acuity is transmitted. It is not the bare thought of 1603 which is operative but something which that piece of information has brought in its wake; a date has led us to something more important than itself – sensitivity – and then made its polite exit.

A cult of information requires a discipline of relevance; but relevance is a complex notion, it requires us to ask: 'Relevant to what, and in what way?' Facts are not all equally relevant. The project of full appreciation of a work of art is a lofty aim and many subtleties and refinements of understanding contribute to its realization. But without these we can generally still enjoy the best of a work: we can still be highly, if not completely, appreciative.

For example, a further way in which the two fronts we have been concerned with differ is in the kinds of pilaster they have in the upper portion. In each the columns or pilasters at the lower level are Corinthian, decorated with the characteristic acanthus leaves curling forwards to create a rich disturbance of light and shadow. In the earlier, simpler church the upper pilasters have the same kind of capital. But at S. Susanna the architect has employed the even more decorative, and comparatively rare, Composite order; this adds the curling ram horns of the Ionic order to the leaves of the Corinthian. Thus the later church façade exploits the elaborate hierarchy of Orders (Tuscan, Doric, Ionic, Corinthian and Composite) to give yet more lift to the upper level. It is a lift which is only marginally visual – the horn-scrolls open out that tiny bit more to the light and ease the stonework inches forwards into the air; but the principal point is the weight of tradition to which it appeals – the spectator's erudite recognition of the Composite as, by definition, more rarefied than the Corinthian. Full appreciation of Maderna's achievement, and a full perceptual recognition of the beauties of the building, require from the spectator a grasp of points such as these. And this is surely to suppose a considerable degree of extraneous learning. Examples of this kind tend to reinforce the feeling that we must know a great deal before we can get to grips with art or architecture and leave us feeling inadequate to respond with any seriousness or depth. Yet this is a misleading – as well as inhibiting – conclusion.

In the learning of a language – to consider an analogous case – you cannot be said to have full mastery of a language until you have command of the subjunctive (so be it!) and can use every weird resource of idiom (how many skeletons are in his cupboard?). Nevertheless, it would be an absurdity – and clearly

recognized as such – to pursue these details as if they constituted the main body of the language. While a spirited and interesting conversation can be conducted without these particular refinements, an assemblage of refinements without the basic structure would lead only to bizarre exchanges. A point which is necessary for the fullest understanding may come into play only at the last moment, once everything else is in place; without broad support the refinement is a mere oddity.

With respect to knowledge about works of art there is, perhaps, a similar hierarchy. Refinements of knowledge may polish an already well-developed appreciation but are hardly at the centre of, or essential to, an intimate relation to the work. Knowing about the Composite order is not terribly important. But the prestige attaching to such information sometimes leaves us attempting to master such details in isolation from the cultivation of the more basic resources – resources which feed an enjoyment of architecture. Over-impressed by these refinements, we may neglect simpler but more important points (as a diet of brandy and truffles will ruin your appetite, even though this is a delightful way to complete a meal).

We are considering one of the major ways in which information is important for the appreciation of art – its capacity to change how we see things. When it does this the gap is bridged between extraneous knowledge and visual engagement. This model of the interaction of knowledge and looking is so attractive that it can come to seem like a touchstone of legitimacy: anything which changes how we see is welcome. But are such changes always beneficial?

Here is one dramatic change of perception described by Arthur Koestler in *The Act of Creation* (1969): a friend of his is given a

Picasso drawing; underestimating the generosity of the donor she assumes it to be a print and hangs it on the staircase. Learning that it is an original she promotes it to the best place in her drawing room, explaining that she now 'sees it differently' although she cannot – when questioned – identify any specific qualities of the drawing which she had not noticed before its promotion.

The change of seeing, Koestler thinks, is due to the impact of an 'interference system', as we might put it (he calls it, harshly, 'snobbery'). This influences the character of perception not by making it more acute, but by bringing in a completely new concern which yields satisfaction – a satisfaction which is then fed back into the perceptual experience. The satisfaction of owning a real Picasso – or seeing the highest-rated façade in Rome – is felt as if it were a satisfaction generated by the look of the object, but in fact it derives from a completely different source. (This phenomenon of 'interference' belongs to a general type and is not limited to engagement with the arts. A parent might really see their child's happy, healthy – but ordinary – face as possessing a ravishing beauty by which all must be dazzled; a developer who stands to make a delightful profit might also see some uninspired housing as rather delightful.)

The slow, fluid process of perceptual discovery, of sifting one's own responses, of putting things together visually is disturbed by an accelerated conviction – a kind of over-excitement ('I've got a real Picasso!') – which brings our perceptual involvement with the object too quickly to its conclusion. There can be changes in how we see things which are not ways of getting closer to the object – not ways of coming to see it better – but only of seeing it under the influence (as it were).

External considerations, intimated as information, can suborn perception and play up to an interference system. One purist

option is to ignore information altogether and say that Koestler's friend must simply forget that the drawing is by Picasso, or that we must close the guidebook. This purism is motivated by the fear that knowing you own a work by a famous artist or knowing you are in the presence of a celebrated building will necessarily be detrimental to the fragile process of visual engagement.

Such a purist aesthetic curiously shares its major assumption with its seeming opposite: the cynical view which holds that all perception is corrupt and prejudiced – because, again, information and external concerns are seen as necessarily interfering with perception. The difference between the two views is that the purist believes that information can be ignored and guarded against if we are ultra-careful, while the cynic holds that we can never escape its baneful influence.

This 'either . . . or' situation is unnecessarily claustrophobic. Each side neglects the ways in which information can helpfully lead the eye and incite, rather than dominate, perception; hence it is neither to be avoided nor is it a corrupting agent. Yet we have to admit that this benign interaction is only a possibility – it is not an inevitable outcome. Each side exaggerates – and distorts – a perfectly real problem: our perceptions can be distorted, information is sometimes prejudicial. The negative sides of the dilemma remind us how sterile information can sometimes be. But whether a particular piece of information – it's a real Picasso; it was completed in 1603 – is stultifying (we stop looking and just bask) or stimulating (we start to notice things and to react) is not determined by the information itself. It is not somehow built into a factual statement about a work of art that it is or is not visually productive: that depends upon what the individual spectator does with the available information. After all, learning that she owned a real Picasso could have encouraged Koestler's friend

to look at it more closely, to attend to the grain and flow of the lines, in short, to see the work more fully. If that had happened her claim to 'see it differently' would be the expression of enhanced engagement, not of snobbery.

The kind of information and knowledge we have been considering up to now is essentially book learning. But not all extraneous understanding which we bring to our engagement with works of art is of this kind. Quite often we possess background knowledge of what might be called the 'material existence of an object': how it was made, what it is made of, the fact it has survived from an earlier era. Such knowledge is 'general' in that it applies equally to very many different instances. Acquaintance with the process of oil painting is relevant to our appreciation of many pictures; awareness of the passage of time may come to play a part in our relation to a whole set of buildings in a particular city.

In his meditations on Venice, Henry James continually draws the reader's attention to the age of the city, to its comparative depradation – comparative, that is, to the days of its greatest splendour when the Serenissima commanded 'a quarter and a half of a quarter' of the civilized world. It crucially contributes, he thus intimates, to our engagement with a building such as San Marco (plate 4) that we realize how old it is, are sensitive to the wear of time and the accumulative character of its construction, that we recognize that the mellow harmony of its surfaces is not the creation of a single day but 'the work of the quiet centuries and of the breath of the salt sea', or (more learnedly) that it was constructed largely of materials pillaged from conquered territories. Many of the statues which now seem to constitute an integral part of the work were taken during the sack of Constantinople – during one of the most wanton acts of barbarism in the history of the West.

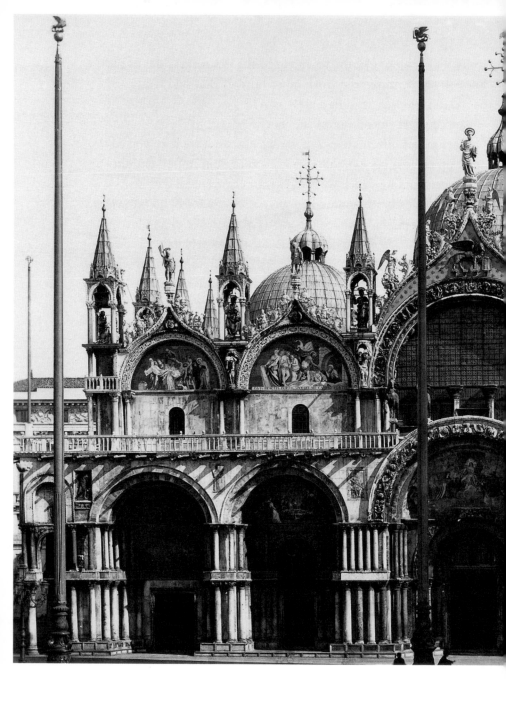

4. Basilica di San Marco, Venice. Does it matter that it is decorated with the spoils of the sack of Constantinople? How do we learn to love a building?

What do these thoughts contribute to our feel for the building? The frailty of grandeur, the caught echo of brilliance now faded, the potential of age to soften, the instance of beauty indifferent to morality – these are themes of human weight. We come to see them in the façade; they are not merely supplements to our visual experience but an aspect of it. They direct attention in part to detail: to texture as showing age; in part to complexity: we see the building as the result of accumulation, not as the realization of a single creative will; in part to the human position of beauty: arising, here, from cruelty and destruction. Background knowledge of this sort feeds into appreciation (when taken up with a James-like willingness to wonder).

Or consider the fact – so obvious that it is almost embarrassing to labour it – that pictures are made by the manual application of paint to a flat surface. Paradoxically, copyists working in galleries (the Louvre seems to have more than any other) often attract keener attention than the original works whose superior merit their own devotion attests. What the copyist offers us – and what the finished work withholds – is acquaintance with the half-lovely, half-tedious process by which a painting comes to be made. We observe with fascination the gradual mixing and smearing of colours on the palette; we enjoy the way the pigment is held on the bristles of different brushes; we take pleasure in the smell of oil and the hopeful areas of primed canvas. The guiding motion of the brush; the transfer of pigment; the motion of finger, wrist and arm; the constant rhythm of attention: original, palette, canvas-in-progress – these are things we enjoy sensually. The materials a painter uses can come to have a charm in their own right, they enrich our sense – in a way which is as yet obscure – of what the painter is about, they inform us about the material nature of painting.

Look at the collection of tools, brushes and paraphernalia of painting belonging to Whistler and preserved under glass at the Hunterian Art Gallery in Glasgow (plate 5). The different palettes for the studio (large, pliable), for outdoor use (compact, solid) and for water-colour (slender, metallic) hint at differences in the physical processes involved. Such items remind us how the action of the brush mixing the colours varies slightly from medium to medium, how the physical posture of the painter is distinct for different kinds of picture. For oil-sketching, the panels on which he will paint slot into the little box in which the pigments are stored: a token of contained immediacy. The very long brushes for large pictures derive not so much from the need to reach up to awkward high parts (like the extension-rollers people have for painting high walls) but rather from the desire to stand at a distance from the canvas – to see it as a whole. All this is vestigially present in the display of equipment and invites us to a sensuous sympathy with those acts. The various sizes of the brush heads reflect relative gestures of work: minutely careful, lavish (the really wide brushes are for preparing the canvas rather than sloshing on gallons of paint); the little jars and tubes of pigment isolate manageable portions of raw matter, already making it tempting; their own aesthetic charm prefigures their eventual transformation into seascapes, ladies in ball gowns, dandies – into the oeuvre of Whistler.

The display brings into focus the continuity of the acts of painting with other more banal activities: the wide brushes for priming canvas, the hammer and pliers for stretching it on to the support. The walking stick possibly found employment as a maulstick – a support employed by some painters to save their arms from fatigue: held against the top of the canvas at an angle it provides a resting place for the painting hand.

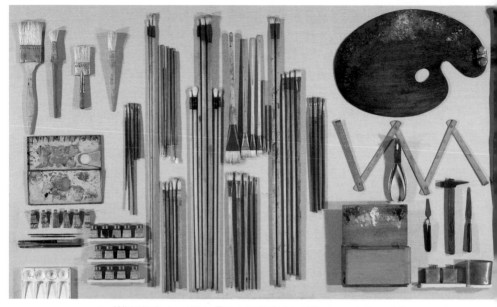

5. Whistler's brushes. The painter's tool kit; a reminder of the complex labour involved in painting a picture.

The brushes and the rest forcibly remind us that painting is, at base, a material struggle. All the varieties of implement – and the layman can only wonder at the variety of specific tasks to which each is individually suitable – are testament to the troublesomeness of the manipulation of oily pigment on canvas; an activity at once appealing and maddeningly difficult. The imagined physical sense of how difficult it is to control oozing and runny stuff on a bit of stretched cloth adds to our admiration of the achievement of the painter. It is an admiration to which the copyist (an unfairly despised agent) ministers, for here we see something of the ordered approach, the taking of the task part by part which, rather than demystifying, enhances our respect for the painter. There is always delight in professional competence in manual

skill, by which the resistance of matter is overcome through the cultivated exercise of mastery – a theme of resonance, given the settled tendency of the world to elude our control.

It is perhaps reverence for this technical process which survives as the complaint, so often brought against contemporary art-works, that 'a child could have done it'. The sophisticated response (doubtless correct) is that a child would not have thought of doing it (exhibiting a bare canvas slashed a few times, painting it completely red). But the retort does not catch the spirit of the complaint. For the complaint seeks after technical skill – the power over resistant materials, the attractive handling of implements – because it finds in such skill something it loves. And it sees in painting not just a finished exhibited thing, but the pre-cipitate of a way of working and the acquisition of mastery which are in themselves to be respected.

Part of what there is to love in, say, Holbein's *The Dance of Death* woodcuts (plate 6) is the fact that the image was won against the recalcitrance of the block; that it was made through the patient efforts of cutting and scraping – that it was a difficult thing to do (difficult, that is, by ordinary standards, because perhaps it was easy for Holbein – which is only another way of grasping his powers). Why is it important to know that this is a woodcut and to have 'background acquaintance' with the physical process of making such a print?

Because it brings into the sphere of contemplative looking the sensuous resources of cutting, of the feel of wood, of the tricki-ness of the business. We gain a deeper feeling for its linearity, its crudity at certain points (the blunt rendition of faces, the avoid-ance of overlap between lines which flattens the sense of depth), the dashes used to indicate contour. The subjects are presented with minimal simplicity, as if in recognition of the labour of

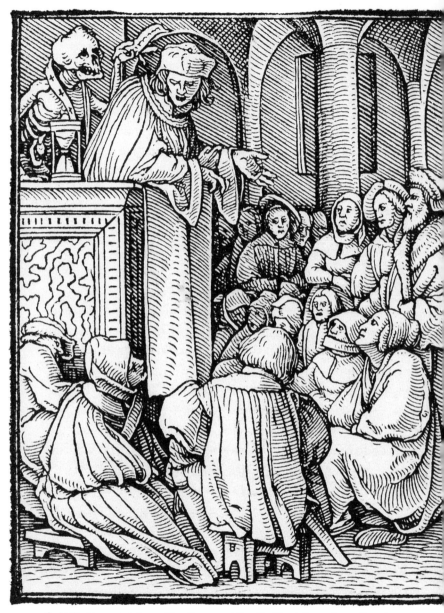

6. Holbein, scene from *The Dance of Death*. The inherent crudity of woodcut as a medium is used to reinforce our fear of death.

producing lines; lines are an effort. There is, of course, nothing in the subject-matter (the presence of death in life) which demands a woodcut treatment; the theme has been portrayed in all media. But Holbein exploits the medium to give a raw feel to the figure of death; the absence of sheen and intricacy here plays up to the rude presentation of an ugly – though sometimes very ironic – motif.

If we look now at Watteau's drawing, *A Lady at Her Toilette* (plate 7), we are faced with a very different material. The variability of the drawn line to pressure, its ease of being rubbed into smooth equality, its suggestive burr which does not indicate a precise edge but likens to the imprecision of shadow, the coarse texture of the paper which brings a visual consistency to the whole and catches the crayon, bringing a speckled quality to all but the darkest areas, making lines seem like a heavier or lighter trail of dust: these are features which arise from the mechanics of the situation – drawing a crayon across a textured surface. Watteau's drawings have the character of spontaneous impressions which seize upon a momentary posture of the body (although they also have compositional roots in traditional poses). While they are attentive to the overall structure of a movement, they also manage to present an intimate sense of the texture of flesh: its elasticity under the arms or foldings over the abdomen.

Along with our sense of the material, we gain a feel for the profligacy of the medium – how easy it is for the draughtsman, how quick, to add another stroke; the imagined pace of drawing, light and rapid, sets it apart from our sense of what is possible in a woodcut.

Background acquaintance with the different techniques which accompany different media plays into our engagement with

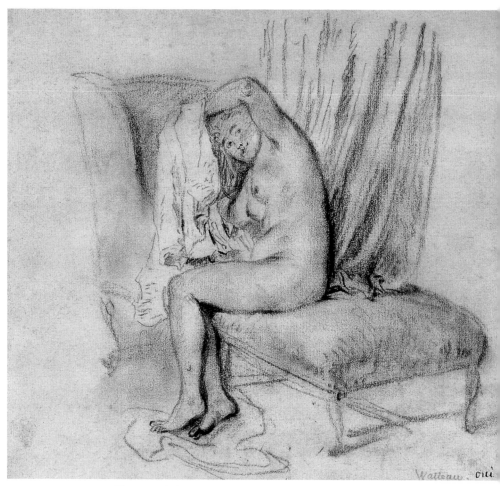

7. Watteau, *A Lady at Her Toilette*. The rapidity of the drawing helps create the feeling of a moment seized.

individual works. Not only does this acquaintance guide our more detailed perceptions of the picture, it also helps us to see the ways in which the artist has worked with, or against, the opportunities and limitations afforded by the medium to bring out particular qualities in the subject-matter. It opens up, in other words, our appreciation of the tie-in between treatment and subject-matter (the woodcut enhances the crudity of death, the texture of a drawn line brings an enhanced impression of the texture of flesh).

The kind of information we have been considering in the latter part of this chapter has one peculiar characteristic. It often shades off into sensitivity. Acquaintance with a medium doesn't require just that we memorize a few propositions, it requires an imaginative feel for the physical qualities of the material and their manipulation. But, of course, this imaginative feel has to be elaborated in the individual experience of each spectator – it has to be grasped from the inside. While it would be rash to suggest that personal acquaintance automatically generates affection, at least it is not surprising if such acquaintance can foster an intimate appeal.

Information, so far as it promotes personal engagement with a particular work of art (as it feeds love), always points to something beyond itself. There is some further thing the spectator does with information – using it to elaborate a feel for the process of making, for the human weight of objects of beauty, for pursuit of the nuances of looking and seeing. But, precisely, doing these things requires more than being informed: it requires the mobilization of resources of attention, sensitivity and thought. To understand this process of interaction – in which something as impersonal as a historical fact is sublimated into an intimate tie

of affection and enthusiasm – we need to know more about these other resources. And it is to this issue that our attention turns in the next chapter.

Resources

Let us look at the case of someone who develops confidence and passion in their engagement with works of art, to see if we can gain an understanding of how this comes about and catch sight of the resources, apart from information, which are drawn upon. Here is a nineteenth-century art-lover writing about the façade of one of his favourite buildings, San Marco in Venice. He describes the great sequence of arches which rise one upon the other

Until at last, as if in ecstasy, the crests of the arches break into a marble foam, and toss themselves far into the blue sky in flashes and wreaths of sculpted spray, as if the breakers on the Lido had been frost bound before they fell, and the sea nymphs had inlaid them with coral and amethyst. John Ruskin, *The Stones of Venice*, Vol. II, Chapter IV

By what route did Ruskin – whose transports before 'the Gothic Crown' we have just witnessed – come to have such an appreciation of this building? In his autobiography, *Praeterita*, Ruskin traces his formation as a lover of painting and architecture. And what do we find? The lists of learned studies read, the pursuit of previously uncovered research, the digging up of manuscripts and tracing about in the archives? Not at all. He describes rapturous childhood hours passed staring out of the window into the street

and his 'excitement during the filling of the water cart, through its leather pipe, from the dripping iron post at the pavement edge'. Another crucial step in his education came in adolescence with his first sight of the Alps from Schaffhausen:

We dined at four, as usual, and the evening being entirely fine went out for a walk, all of us, – my father and Mother and Mary and I . . . there was no thought in any of us for a moment of there being clouds. They were clear as crystal. Sharp on the pure horizon sky, and already tinged with rose by the setting sun. Infinitely beyond all that we had ever thought or dreamed, – the seen walls of lost Eden could not have been more beautiful to us; not more awful, round heaven the walls of sacred death. *Praeterita*, Vol. 1, Ch. 6, section 134

In Ruskin's life it was the time he spent in the garden of his parents' house in South London, wandering, playing and looking on his own, that provided the grounds for his later attachment to art. The plants, the change of light from morning to evening, the motion and character of the clouds, the shapes of leaves and petals and his own imaginative wondering were the material out of which his later formidable capacities as a critic and connoisseur were fashioned, but which also gave rise to the passionate involvement he came to feel in the achievements of the artists who meant the most to him. And on his early travels (accompanying his parents) it was less the formal moments of encounter with masterpieces and more the surrounding atmosphere of a small town, or a picnic by a waterfall, that made the deepest impression.

The experiences Ruskin dwells upon are not particularly momentous in themselves (although they were momentous for him); if some of them seem tailor-made for an up-and-coming

aesthete, this is misleading. As if facing this very issue, Ruskin discusses the formation of Turner (his favourite English painter), who grew up in a dark alley-way off London's Covent Garden with never an Alp in view. What did it have to offer? Well,

Dusty sunbeams up or down the street on summer mornings; deep furrowed cabbage leaves at the greengrocer's magnificence of oranges in wheelbarrows round the corner; and Thames' shore within three minutes race. 'The Two Boyhoods', *Modern Painters*, Vol. V

Experience of special, privileged objects is not, then, the needful thing; what counts is that the experiences are delighted in, dwelt upon, mobilized and made use of. What we need is 'to take an interest in the world of Covent Garden' – or whatever bit of the world it is we encounter – 'and put to use such spectacles of life as it affords'. It is from such experiences that deep engagement with works of art emerges. And the story is true in type wherever, almost, one looks, from Goethe to Proust.

Ruskin's case gives rise to potentially unsettling reflections. The adult who responds to art with passion finds – in this instance – the sources of that passion in his early years and lonelier moments. Intensity of visual experience was something he learned young – when response is at its freshest, when delight in the mere existence of things is easiest to come by, and it was learned, mostly, when he was on his own – when he was left to look at things in his own time and under the impulse of his own curiosity. This does not amount to a programme of education in art appreciation that could be codified and packaged for a class-room course. The experiences at the heart of his education were not deliberately sought out and they occurred before the age of

reason – before Ruskin could have had any sense of the role they would later have in his receptivity to art. His sensibility was cultivated by good fortune and temperament before it was trained by learning.

Cultivation and learning: cultivation is oblique, trying doesn't necessarily help – the aim cannot be approached straight on. The wayward relation to effort makes cultivation slightly suspicious (for one of our major hopes in life is that effort will be rewarded). It is part of the weirdness of art – part of what brings it into the domain of leisure and part of what makes it an awkward subject for professional study – that responsiveness to art, particularly the deeply felt responsiveness of a Ruskin, has its roots in something you cannot make an effort with, something you cannot learn by learning facts and theories. And that something is a private history of perception.

Someone who hardly knows 'the first thing about art' – in terms of specialist information – still finds that the door stands ever open to a fruitful encounter with individual works of art. That person already possesses, perhaps, the resources which constitute a good ground for engaging with art. A child might be struck by the red autumn leaves lying on green grass; a patch of sunlight in the distance tempts the eye and makes one feel how nice it would be to be over there; for a moment one stares intently at a wooden fence in a suburban street, absorbed in the various marks and stains which make so rich its otherwise banal surface; the slope of a meadow down to a line of old trees in the late afternoon; a rose sky at the end of a regular city street; a dank lakeside – perceptual memories like these provide us with the material out of which we can fashion a personal relationship to a work of art. Or perhaps it is the childhood intrigue of visiting people's houses and getting acquainted with the different

dispositions of rooms and space and textures upon which one draws; or the wonder of public spaces in old-fashioned hotels.

We each have our own history of impassioned looking – of looking which is woven through with feeling. The experiences differ in phenomenal quality: some are tender, others haunting, some sweet or playful, or again stamped with nobility and grandeur. They may be recalled as fugitive and hard to pin down, as existing in an Arcadian period from which we are now cut off; they may seem crystalline, they may be inviting and invigorating or touched by sadness and uncertain longing. That is, we are all already acquainted with the extraordinarily subtle ways in which feeling gets linked to vision and memory; we already possess, if only we can make use of it, the most important resource for looking at art.

When these personal resources are mobilized in looking at a picture or a building, it comes to live in us – it gradually takes a place as part of our imaginative stock. Everyone has these resources, but we are not always able to make use of them; so one important question concerns how we can make use of the capacities we already have.

Apart from a specific history, we also have general perceptual capacities, or capacities linked to perception. These more general qualities are essential to the character of our engagement with art. We have sensitivities of sensual reaction, we have powers – or failings – of concentration, of visual synthesis and individuation, of patience and the capacity for reverie. These are central to building up a relationship with an individual work of art.

Of these resources, sensuality is perhaps the simplest. If we take pleasure in walking along the Calle Riello (plate 8), or one of the many similar streets in Venice, it will perhaps be in part because

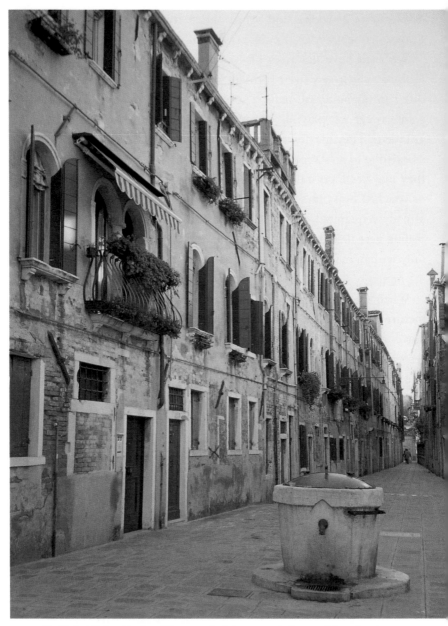

8. Calle Riello, Venice. The wonderful, sensual shape of the street reminds us how comfortable architecture can be.

we like the materials from which the buildings have been made. (What would the Calle lose if it were reconstructed in wood or plastic, retaining its shape but being transformed in texture?) We enjoy the imagined feel of plaster and brick, of painted wood and iron.

We might imagine what it would be like to push open one of the round-headed shutters and feel its divided panels swing out and back; or imagine gripping an iron strut in one of the window grilles to feel its resistant strength. As we stroll by we might fancy what it is like to pass under one of the low doorways to explore what is going on inside. The wall comes to be seen as the exterior of a row of homes whose interiors push through at windows and doorways. This thought has a sensuous aspect as we imagine what it would be like to look out from the confined, private space into the communal street (a feeling which can be enviously heightened if we pass when someone is frying a cutlet or making coffee or listening to something nice on the radio – anything which fleshes out an attractive life led within the row).

Even the plants in their terracotta pots and window-boxes contribute a contrastive feel: their silky freshness helps bring out the crumbling, aged quality of the walls. And if we have chosen the early part of a summer's day, we might appreciate the cool air which lingers in the narrow street and sense in the pink warmth of the sun on the upper walls a hint of the prospective heat of the day. The overall shape of the Calle swells and narrows like an abdomen; it is organic, elegant and smooth: the shape of some-thing it would be nice to turn in one's hand.

This sensuous responsiveness and its imaginative extension is central to finding a place comfortable. Comfort, curiously, is not restricted to the immediate sensations of the body; you can be seated in a cosy armchair but feel uncomfortable because your

hotel room is an awkward shape, the bathroom intruding into the original volume, leaving peculiar angles and alcoves. Not actually restricted, you feel constricted; there is no direct bodily irritation but the objects of sight present irritating textures and shapes. Sensuality, in other words, though rooted in the sensitivity of skin, is a projective and imaginative capacity.

Or it may be that the street is found restful. But what is it to find something restful? It is to be aware of a degree of encouragement to relaxation and security. It may come as a surprise to reflect that, in the appreciation of architecture, we have to be alive to feelings we probably know more usually when lying in bed – feelings which, unexpectedly perhaps, can come into play when walking down a street looking at a row of old houses.

The clear volumes, the refined proportions of the Badia Fiesolana near Florence (plate 9) are sympathetic to a feeling of calm, a mood of purity and concentration in which the eye likes to glide without anything to disturb it, with only a few discreet and pure accents to help it more easily along its path. This is the kind of space in which to recover from carsickness or a hangover; it treats each sense with delicacy, it makes no demands of effort upon us, yet it does not leave us in formless anxiety but gives something to repose upon. Elements are kept plainly distinct, there is none of the slipping between portions which can be so disagreeable in a delicate frame of mind and which is the essence of a sense of dirt and disgust.

But if we were to make our way across Tuscany to Siena and approach the Church of the Chiocciola (plate 10) we would be invited to a very different sensory mood. It is, here, a feeling for flowing things, for the curl and draw of waves, which is teased out: our feeling for things being flexed and turned, even strained (like a good stretch), which is played up to. There is exuberance,

a mingling of parts, as the central niche breaks into the pediment; there is a teeming quality, as the side half-arches turn redundantly but energetically into space and testify to the pleasure of excess. It is a building for a lazy lingering look because it does so much work for us; it does not upbraid an unbraced feeling by being cool and focused, it encourages self-indulgence (an ideal setting for early-evening drinks with the prospect of a lush evening ahead of us).

These buildings share the classical idiom: they exploit the rule of columns and cornices, capitals and architraves. The difference in the way the idiom is treated can be described dispassionately but we have seen how it might be an overall feel which leads us to see – as we try to account for our general sensory impression – what the salient differences are and to start referring to early Renaissance simplicity and mannerist playfulness. Here we witness a benign interplay of feeling and perception: one stimulates and feeds the other. A knowledge of stylistic categories can proceed from the inside – if we attend to our own reactions – rather than from the outside (as when we read up in advance about the ways in which deviations from Vitruvian orthodoxy can be plotted as a series of grammatical transformations).

A private passion for these buildings comes from the striking together of the mood each captures and an internal need of one's own. It may be that one of them reflects and encourages a mood we already know and are in comfortable possession of, and the satisfaction is in the presence of something familiar and already well liked. Or it might be that a building serves to fix outside of us a lasting version of a state we enjoy too rarely and fugitively, but which we prize. (For me the Badia realizes a mood I would love to hold on to, but despair of in daily life.)

*

9. Badia Fiesolana, Florence. Calm, ordered space: a good place to recover from a hangover.

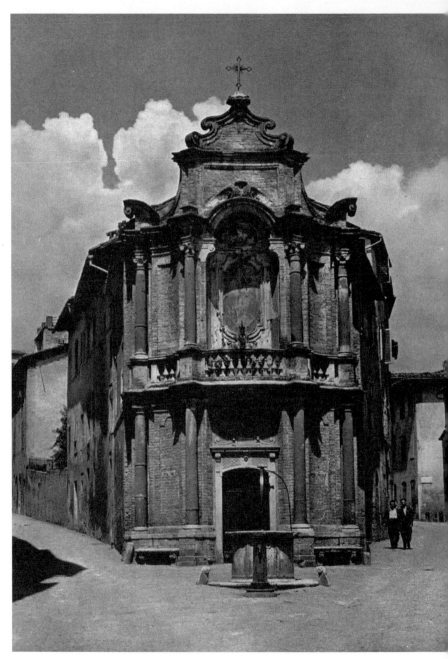

10. Church of the Chiocciola, Siena. Classical architecture at play; the perfect backdrop for a festive evening.

How might this resource of sensuous imagination work when we stop before a picture in a public collection and start to look at it? Suppose we find ourselves looking at a lesser-known work like the *Ponte delle Navi* by Bellotto (plate 11), whose work has always been much less well known that that of his uncle and master, Canaletto; unfairly, in my view. We can see at once that it's a 'classic': it's all shimmering with cool tones and silky textures. We get up close and see the precision: so many details, all the little waves and bricks minutely rendered. But it's hard to 'get into' the picture – attention gets lost in the big empty space of the sky and we become mesmerized by the minutiae; despite all the water it feels dry. We could easily leave off here and pass on to the next picture. But if we give the painting a little time and try to make use of private response to the visual features of the work, it may start to unfold before us. We begin to be sensitive to the sluggish quality of the river and the sharp solidity of stone, to the lightness of the air and the warmth of sunshine. We come alive to the transient human element – if I can call us that – in contrast to the persisting aged stone; and yet the stone itself is impermanent and worn by the sky and river.

From the point of view from which they have been depicted, the central buildings on the bridge have a highly refined asymmetrical poise; as we dwell on it, this effect is seen to depend both upon the represented qualities of the buildings (what they were like in reality) and upon the disposition on the surface of the canvas. On the picture surface the longer crenellated parapet runs upwards but, of course, it represents a horizontal line, and in looking we become aware of both these aspects, each of which contributes to the energetic stillness of the group. This complexity is worked in with a further apposition of crumbling, worn fabric and stark geometrical order – an order further enhanced visually

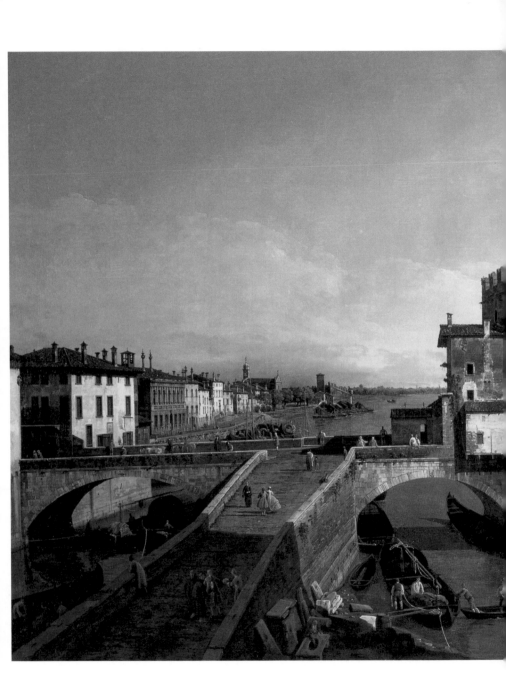

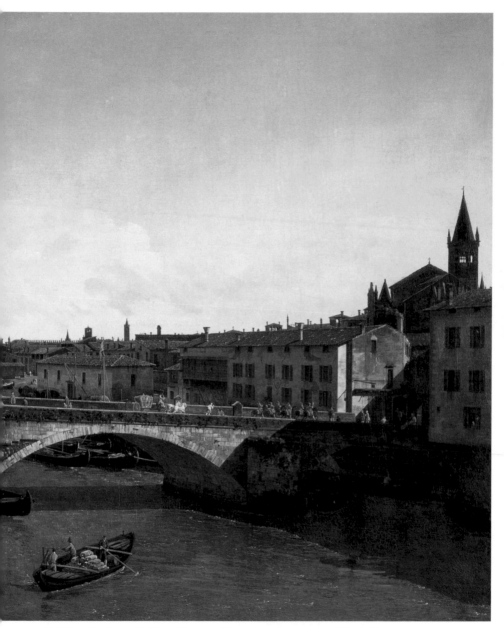

11. Bellotto, *Ponte delle Navi, Verona*. The crisp stonework of the bridge contrasts with the sluggish motion of the river. What kind of knowledge is required to enjoy that?

by the sharp fall of light and shadow. We are struck too by the fact (and it comes to strike us as an amazing fact) that this is a *painted* representation. This is particularly poignant as the river breaks on the leading buttress – the light cap of foam is a fleck of white paint applied on a lower, dark stratum; we see the characteristic shape of the watery motion being made from a delicately placed stroke.

If we let our attention move out from the central grouping and hold the whole width of the bridge in view, we attend not only to the representation of an incredibly attractive thoroughfare but we have, at the same time, a strong impression of rhythmical unity. The weight of the central building is held between two light spans – their apparent lightness achieved by picking out only the lower, arching masonry in strong sunlight. And if we bring in, too, the ramp leading up from the lower edge (on our left) we are presented with a tensed and complex form which stretches across the whole width of the picture, drawing it forcibly together like the visual equivalent of a (highly refined) elastic band.

What we contemplate here – if we attend patiently and actively enough – has not emerged through the application of prior knowledge to an initially resistant picture. What has happened, as we spend time looking at it, is that our capacity for sensual response has been brought into service, trusted and followed as a guide to the picture. We have to see the material qualities of what is presented (the solidity of the keep, the gentle flow of the river) and feel the contrast between them in order to appreciate the picture. These we have come to experience directly and for ourselves. Although it may happen that we are alerted to various subtleties (like the asymmetrical balance of the bridge), a critical benefactor is of help only as a prompt to our own visual encounter with the work.

*

The personal resources for looking (of which sensuality is an important instance) are transferable skills: sensitivity to the contrast between sharp and soft, solid and ethereal, developed in engagement with one picture, is usable in looking at many other works. Learning how to look at one picture or building in this way – making use of the second things we know – stands it in good stead for looking at others. Contrast this fecundity with a more information-based approach to art: the sort of approach which places knowledge of a great many historical details at the centre of our engagement. You could have this information spilling out of your ears about one picture and be none the wiser when you come to the next picture which was painted under different conditions – you have to start all over again.

Then again, if the next picture was painted under similar condition you are not well placed to see how it differs from the first. Consider Bellotto's *View of Verona from the Ponte Nuovo* (plate 12), which was probably painted as a pendant to the other Verona picture we have just been looking at. If we have a feeling for the relation of keep to sky in the first picture then we are well prepared to respond to the campanile and the clouds behind, or the towers of the fortress rising into the air, in the new one. We still need an eye for the different textures of water and stone; we still need to be charmed by sunlight on masonry, or by the general subdued tone of the picture. The relation of campanile to fort as mass calling to mass – and as contrastive in a way that makes us more sensitive to the particularity of each – are qualities we may come to see for ourselves in this picture. But having recognized the quality, we might return to the *Ponte delle Navi* picture and see more keenly the relation between the keep and the sloping quay in that work.

Given world enough and time, it would be a fine thing to

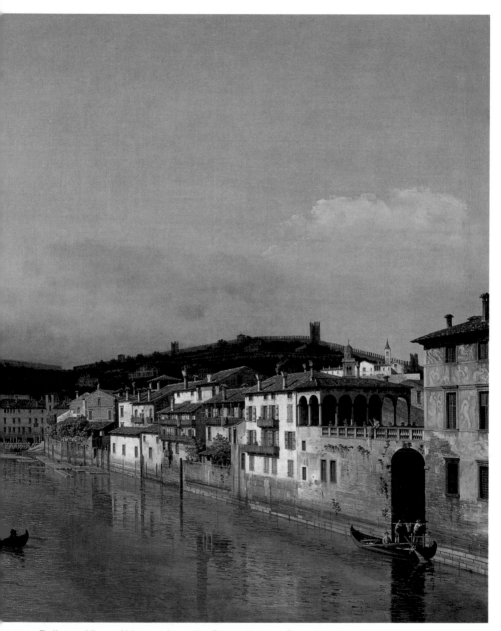

12. Bellotto, *View of Verona from the Ponte Nuovo*. One side of the picture calls to the other. Getting a feel for one painting helps when it comes to looking at others, but why is this?

know all the background details about the pictures; in reality this isn't an option. Transferable skills are essential. But not only as a way of saving time: appreciation of painting is largely a matter of transferable skill. We are getting hold not only of a pragmatically useful approach to pictures we don't know much about but also of something which lies at the heart of any adequate account of art: love of one picture fosters love of another. The scope of transfer can be wide. A sensibility cultivated in the contemplation of a painting by Bellotto could provide the ground for appreciation of an apparently very different work, perhaps an oil sketch of the beach at Etaples on the Brittany coast by Peploe (plate 13). Peploe's lack of concern with individuating detail is strikingly different from Bellotto's attentive delineation. But if we have developed an eye and a taste for the way Bellotto plays off the whitish grey of a bridge and the green of a river, we might in turn be responsive to the grey and blue brought together in Peploe's work. Or if we have dwelt with pleasure on the patina of the stonework which Bellotto invites us to enjoy – or the lichen and the weather stains, the swirling eddies of the water – then we are well prepared to enjoy the free pattern Peploe derives from the figures on the beach and the swirling quality he imparts to the brushwork depicting sea and sky.

Sensitivity to place, to the evocation of time of day, to the sky above human life – if we can develop these qualities while looking at Bellotto, then perhaps we can respond to the sense of place and the expansive sky in Peploe, even though they are generated in quite a different way.

This account of interest in art sheds light on an otherwise obscure issue: the continuity of our artistic interests and the rest of life. Continuity, because the kinds of experiences we have of works of

art often have much in common with the experiences we know outside of that privileged arena. This is unsurprising if interest in art draws – as I have suggested – upon a wide range of resources; resources which are extra-artistic in origin and character. Much the same sensibility goes into having an eye for a well-cut jacket, a brass bath tap, a sleek car, as goes into the appreciation of a work of art. (There are differences at the level of meaning – the tap doesn't articulate an idea or embody a compelling vision of life, but it does appeal to our sense of shape and texture, our feel for solidity and straightforwardness and our hopes for a purifying immersion.)

This continuity can be reassuring, not least because we usually feel greater freedom and assurance in response to objects which are not classed as art, than we do when confronting works which have been dignified by that title. Someone driving near Florence might respond with delight to the patterns of sun and shade on the road, the crisp masonry and the gracious curves of the walls on either side, to the lovely interplay of two arches and the glimpse of a shady street as they speed by (plate 14). The visual sensibility at work in these normal reactions is essentially the same as that which goes into the appreciation of works of art. It is the common set of resources we draw upon in engaging with them which illuminates the kinship between a non-art scene like this and works of art themselves.

Recognition of this kinship is valuable to both parties. The relaxed enjoyment of the roadway can be recruited to the enjoyment of Bellotto. On the one hand, we can take our enjoyment of real sunshine and real walls and real arches and make use of them in appreciating what Bellotto has done in depicting elements of this kind. He has played up to these pleasures and enticed this sensibility by giving it a wonderfully rich – and

13. Peploe, *Etaples*. Transfer: what can the old masters teach us about Peploe, or he about them?

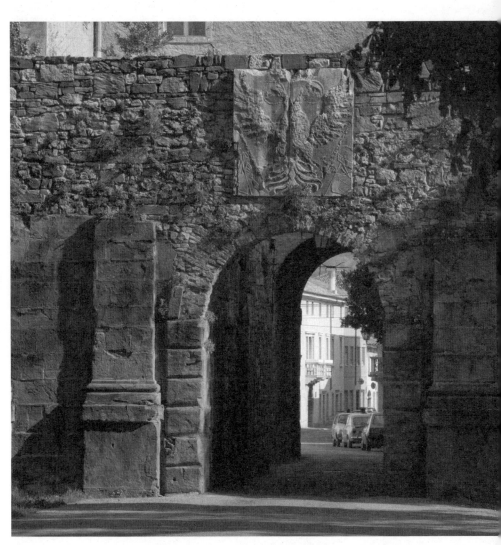

14. Portal to Gradisca d'Isonzo. The education in looking that we receive in the gallery enhances the pleasures of driving.

permanent – home. We can see him as a familiar and friendly painter rather than as a moribund figure of the past.

On the other hand, seeing the continuity between enjoyment of the picture and the roadway (to run the equation in the other direction) gives a dignity and weight to the pleasure taken in such a sight. Rather than regarding it as a mere passing frisson, we see that others have taken these visual qualities with great seriousness; and this may encourage us to take seriously the satisfaction such a scene affords.

Reverie

What good we get from art depends upon the quality of our visual engagement with particular works. We need to 'learn to look'; but that phrase has an odd ring to it: don't we know how to look already? With the words 'see' and 'look', however, language gestures at a crucial difference in types of visual experience.

Imagine we are in Siena, standing before the Palazzo Tolomei (plate 15), eyes open and not totally preoccupied with the prospect of lunch. We can't help seeing the building (we're not in any danger of bumping into it): this is minimal visual recognition and what students of visual processing call a 'fast mandatory reaction'. By contrast, there are other visual processes which happen more slowly and which don't have to take place (and which sometimes don't occur at all). No one wants to suggest that you can really come to see the architecture and have a feel for its visual qualities in the blinking of an eye.

But what exactly are these other processes and why do they take time? What role do they play in the appreciation of art? To ask this is to ask more about the resources individual spectators bring to their encounter with works of art – and about the deployment of those resources. What is the process of visual engagement in which a sense of something being interesting, or mattering personally, comes to the fore?

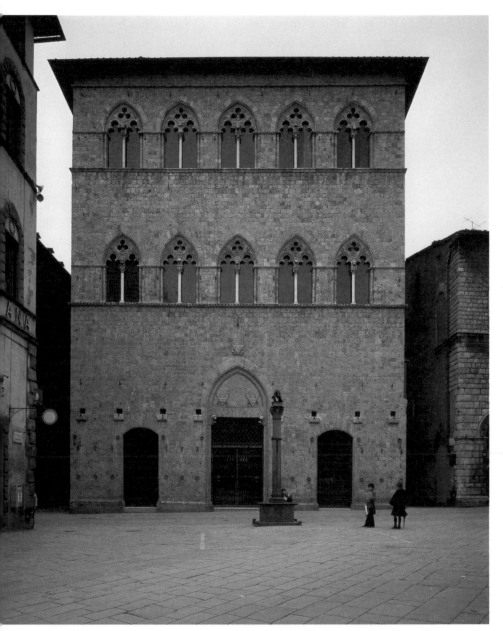

15. Palazzo Tolomei, Siena. What is the difference between just seeing
that the building is there and learning to look at it?

We are, among other things, associating machines. Feed in an object (a smell, a word, an image) and it excites in the imagination a corresponding item (a feeling, a recollection, a hope). It is only natural that associations should quickly surface when we look at works of art (for they quickly surface all the time); certainly a large proportion of conversations in galleries involve people telling each other what the pictures bring to mind. This is one of the major native resources we bring with us when we visit a gallery or distinguished building.

Autumn Sunshine, by the late nineteenth- and early twentieth-century painter Edward Arthur Walton (plate 16), is liable to provoke thoughts about the last time we saw a cow, childhood holidays, driving in the country – or it may be that the way the foreground is built up in individual patches reminds us, slightly, of Cézanne. The Walton picture is of a troubling kind. We have never heard of Walton (is he considered a genius, a tedious old fool?) and so have no expectations about how we should approach his picture; there is no internal script to prompt us as we look at it. Fame furnishes clues about what to do: look at Mona Lisa's smile; home in on the shadows in Rembrandt; with Hals it's the eye you go for; with Vermeer you're primed for stillness and intrigue. But with a painter called Walton? And Walton's style seems unremarkable: neither a *tour de force* of imitation whose virtuosity excites, nor something rich and strange which appeals through its revelation of a unique temperament. We are on the verge of considering it a dull picture and passing on. Is it confessing too much to admit that a great many pictures belong to this category?

The private track of association (potentially) gives access to the picture; it provides a way of linking an external public object, which is about to be boring, with the fabric of individual life; it

offers to make the picture personal. But how is this potential to be realized, how do we take up the offer?

If we let them, associations come in gangs and each is the spring to yet others. In general, we keep the progeny under close control. Reverie, by contrast, is the state of giving ourselves up to the flow of associations; it is a passivity of the mind which allows the activity of associations to go on unimpeded. (It belongs to the class of things we can do only when we don't try.) This state of letting something happen – a species of relaxation – is one we need to cultivate when we look at paintings or buildings. If we go to them demanding that something special happen we end up in the lamentable condition of the insomniac who can't sleep precisely because he keeps telling himself, with mounting panic, that he must fall asleep. And then it is no good ordering ourselves to stop trying. We need to relax, but it is anxiety-provoking to be told to do so.

Inhibition may occur if we dismiss reverie as 'idle thoughts' – too silly and impertinent to be allowed in an art gallery (in fact the opposite is true, as the rest of this chapter seeks to show). But there is another, deeper kind of inhibition: for quite interesting reasons reverie sometimes feels unproductive. A nascent, undeveloped thought (the kind of thought we often have in a moment of reverie) might seem idle because we don't know what to do with it. The slowness of reverie – it takes time for a thought to float into consciousness – may feel, disconcertingly, like going blank, just at the moment when we suppose we should be most switched on. We panic and abort the developing thought.

If this doesn't happen, the very abundance of associations which pile up may overwhelm us, we experience their polyphony as swirling confusion. Reverie is hard to sustain: as we pick up

16. Walton, *Autumn Sunshine*. This picture reminds me of something. But what? And how?

one theme we lose sight of another; we get distracted and the fragile links are broken; we move on too quickly before we can take in the complex structure which we are spinning for ourselves. We are profligate, wasteful with our creations. We not only need to let ourselves follow our associations, we also have to work with our reverie in order to harness it as a resource for looking at pictures and buildings.

One of the things which makes reverie tricky is that we can't always bring to present consciousness the association we search for, even though we have a presentiment that 'something is there'. What is it those trees and cows suggest; what does the foreground ridge and the glimpse of a further slope bring to mind? They evoke something in me, only I have difficulty saying what it is.

In the *Meno* – where Plato is trying to understand how we can know something without knowing that we know it – he imagined the mind as an aviary. Our mental cage is filled with images and thoughts which flutter about, really there but often just out of reach. We may not be able to seize them at any particular moment, we may have to wait until they settle of their own accord.

Though apt, the metaphor is misleading in one important respect. It suggests that what we are searching for in ourselves is already crystallized – just temporarily out of reach. But the association after which I am groping may not yet be well formed; I may have to work to give resolution to something which is as yet nebulous and inchoate in my mind – as much of our undigested experience is.

Associations follow a personal route. The clump of mature trees on the left in Walton's picture makes me think of some trees I came across in my childhood, on a long walk quite late in the

afternoon, with the sense that I had never roamed so far on my own before. The smaller tree on the right looks a bit like a sapling I quite often pass when I go for a walk. But so what? What these associations share is not only a sense of isolation but a beseeching quality, as if the trees were waiting for someone to come along. The initial associations – two remembered trees from very different stages of my life – unfold to reveal a common quality of tender loneliness. The picture brings this common quality to mind, but only indirectly; by way, first, of associations to other objects which are also linked in my mind to that feeling of isolation. It is often not easy to get hold of this common quality, it slips from our grasp; we sense that there is some connection between the associated items, but we have difficulty seeing what it is. It takes the slow time of reverie for this to settle and become distinct.

The half-cover of the sky, the pale blue with white and grey reminds me of a train journey to Scotland; the sky looked just like that and I felt (partly as an effect of travelling) that time was stilled and that the tranquil afternoon would last indefinitely and that all the haste and press of my ordinary life would be suspended. In addition, the picture seems to capture, for me, a sense of hope. Not the hope of any particular outcome, but in its offering of simple satisfaction, the hope that I will be able to take more satisfaction of this kind: a kind which, in the picture, looks easily available. Through association, which Freud – the person whom one most freely associates with association – would call a screen memory, we gain access to a further thought or feeling. The screen is, as it were, the bearer of a second and ultimately more important thought – though a more elusive one. Tracing associations from the picture, teasing out their common themes and relating them back to the picture is a perpetual motion. The picture is not only connected with loneliness (one of my first

links) but also with tranquillity which qualifies it. And it is important to draw out the way in which associations get sustained by the picture – not every link I make ends up counting in my longer-term response to the picture. I may come, on reflection, to think that a mood or fancy I am put in mind of takes me away from the picture and doesn't help bring out what is there in it; but quite often what happens is that a memory or personal link helps us to get hold of a quality which, in the end, we do want to say belongs to the picture and is not just a personal projection on to it. Hence the motion backwards and forwards (as it were) from picture to association, from association to picture.

The difficulties posed by following through the process of reverie might occasionally derive from the painfulness of the underlying thoughts and feelings. Certainly this was at the heart of Freud's explanation why certain thoughts cannot be accessed directly but only by means of screen memories which then have to be bravely interrogated to yield their painful sub-stratum. This might occasionally be true of our engagement with art. But a more common difficulty seems to be one more akin to the difficulty of creation itself. It is definitional of reverie that the liaisons between moments of wandering thought are loose and inexplicit; it's hard for us to see where reverie is going. We have, as it were, to create a work in our own minds, to deal – as the artist has to deal – with intractable and delicate material to which we have to give order. And, as with creation in general, it is something we do on our own.

Not only is it hard to see where reverie is going, it can be hard to see where it is coming from. What exactly is it in the picture which has provoked the reverie in the first place? It is in following through this inquiry that we reap one of the principal rewards of reverie. It may require time and concentration to home in on

the fact that it is the low angle of vision, or the odd crook of a branch, or a wavering horizon which is the active element, which is (at it were) searching out some distant part of me and bringing it to the foreground. In the childhood memory of the clump of trees, I now realize, it was walking up towards the trees, with the sense of their being above me, which was sticking in my mind. The association leads me back into the picture with an enhanced sense of what is going on, visually, within it. We only get to notice this by holding on to our reverie and using it to probe the picture.

All this certainly gives us something to do in the gallery, but is reverie only a way of alleviating boredom: is it useful only if something is going wrong, or does it have some more positive value of its own?

Reverie is a mode of introducing personal material into a picture or a building: it brings an abundance of thoughts and feelings into play. It also frees us from merely following routine assumptions. The word itself derives from the Old French 'revel'. Etymology here helps draw our attention to the vagabond quality of associations: they don't follow the expected or standard line, so more interesting moods and ideas can enter this way into our relationship with a work of art.

Among the charms of the eighteenth century is the way in which one of its most prominent political theorists could write with equal seriousness about his private reveries. Towards the close of his turbulent life Jean-Jacques Rousseau wrote a series of essays recounting thoughts which came to him on his habitual strolls in the meadows around Paris. The aim was to provide 'a faithful record of my solitary walks and the reveries which filled them when I let my mind go free and my ideas follow their own inclinations without resistance or obstacle'. But why did

Rousseau think this was a good thing – something to be cultivated rather than a waste of time? Or, in the case of *Autumn Sunshine*, what is so good about uncovering a link between a painting and a memory of looking at some trees in one's childhood?

Rousseau claimed that reverie returns us to ourselves. If we are to make anything of the notion of being 'returned', we have to have a clear sense of what it is to be absent from oneself. Clarification is an urgent need here because the very idea seems contradictory: How can I be absent from myself when I am myself? Rousseau was highly sensitive to the way in which our sense of identity – our sense of who we are – can be largely given over to simply coping with living in society. We are in danger, Rousseau thought, of forgetting who we are; not in the sense of forgetting our names and addresses, but in terms of forgetting what is important to us. He took himself as a case in point.

Rousseau was obsessed with what other people thought of him, and was thoroughly frustrated by this obsession. He was often worried about money, he frequently felt paralysed by embarrassment, overtaken by lust, oppressed by his surroundings (he was fairly normal). These distractions took away his self-possession: they were continually hijacking his thoughts, they threatened to absorb him completely. But how then to answer the question '*Que suis-je moi-même?*' What am I in and of myself? If he left aside the pressures and distractions of society, all the claims that others made upon him, what was he then? His own reveries, as he recounts them, involved Rousseau in mental wanderings through what often seem like minor incidents in his past. The fifth of the 'walks' recollects the 'true happiness' he found when on an island on the lake at Neûchatel near the Swiss–French border: 'With the onset of evening I would descend

the low cliffs and set myself down pleasantly near the shore in some sheltered spot; the sound of the waves and the movement of the water held my attention taking away all other agitation from my soul.' This reverie not only returns Rousseau, in imagination, to a happy time, it helps him remember who he is: he is someone who finds happiness in a simple and undramatic way, on his own. Rather than indulge the social fiction he had nearly become (for whom life is a matter of riches, public honours, reputation and the like), he identifies himself with a very different – and to him, more convincing – conception of what matters. Daily life does not encourage us to admit that we are often confused about what is important to us. In reverie we are returned, in contrast to the distracted way we often exist.

Rousseau's image was of a pure and simple self, with easy pleasures and natural joys, continually prey to corrupting influences. We don't have to be ardent Rousseauists to accept that he has detailed part of the story of what can happen to us. We need not think that society is nothing but a conglomerate of corrupting forces to recognize that there are some things which matter to us which social pressures incline us to forget. We don't have to think that the self we sometimes forget is pure and simple, to think that there are aspects of ourselves we like and value which are not given much space in much of our ordinary existence. Of course it would be over-hopeful to think that a few minutes of reverie in front of a picture will bring about a revolution in our sense of identity and return us to ourselves. It is not to be supposed that the experience of looking at a picture will quickly achieve something as important and elusive as this. But it might help.

Having identified a capacity of the mind and of the perceptual system, it can always be asked how central this is to the overall

cognitive economy. Where does it fit in? Have we alighted upon a protean capacity which is at the core of human identity, or a species of decoration: a kind of garnish to the mind without which we could get along perfectly well? How deeply is the need for reverie ingrained in human life?

The process of reverie which we have been considering is one in which thoughts which are apparently disjointed are found to have a common theme, in which thoughts which are at first light-weight and almost random come to cohere around an object and take on weight. The process of holding on to apparently disparate elements of thought and bits of half-formed feeling and letting them coalesce into a coherent and revealing order – which can in turn be integrated with further thoughts and feelings – is one of the central capacities of the mind. It stands as an image of scientific procedure. 'If a new result is to have any value,' according to the celebrated mathematician Henri Poincaré, 'it must unite elements long since known, but till now scattered and seemingly foreign to each other, and suddenly introduce order where the appearance of disorder reigned.'

This is an exalted task – scientific discovery is not an everyday occupation, but something like reverie plays its part in the developmental processes of a child's thought. How, we might ask, does a child come to be able to think in the first place? What are the mental processes prior to propositional thinking ('that's a tree over there'; 'here's daddy again') out of which propositional thinking grows? What is the wild surmise which first comes to an infant: this set of smells, sounds, opportunities, frustrations, touches, holdings, putting downs, tensions and relaxations is 'mummy'? These elements, we might suppose, are gradually put together in the child's imagination, even though it can have no precise understanding in advance of how they all belong together.

It would be an exaggeration to say that *Autumn Sunshine* strikes us, at first, as a disordered and confusing mass of sensation and impressions which has – as in the manner of infantile experience or scientific data – to be worked up to a coherent whole. Nevertheless, there may still be a gradual, reverie-led putting together of elements which helps reveal the qualities of the picture. The half-clouded sky 'goes with' the woman who is obscured in the shadow of the large trees; the bright barrenness of the low hillside to the right 'goes with' the low angle of vision. What this 'going with' comes to is just that we discern a similarity of feeling, or mood, in these features as they are presented in the picture. In the end love of a particular painter often rests on the fact that you keep on finding combinations of this kind which make intuitive sense to you. You feel as if, in that work, the painter has probed the inner workings of your feelings and displayed them to you with more power and precision than you could have done yourself.

But, of course, we do not come to a picture with a ready-made catalogue of moods that it might capture, nor a list of likely linkages within it. We have to find these ourselves in our visual encounter with the work. We have to let the different feelings which different parts of the work evoke come to consciousness in their own time; we have to be alert to the way in which different elements (a figure, a cloud) relate to one another. There is nothing to guide us in the finding of these linkages except consultation of our own response.

Reverie operates at the root of thinking: it is essential to the creative process in which we come to make thoughts for ourselves, whether we are scientists or babies or something in between. A work of art can be endowed with the quality of presentiment, generating the attractive suspicion that something

important is there for us before we can lay hands on it. *Autumn Sunshine* is like the visualization of a reverie, as if it records the painter's reverie and survives as a witness to the value he set upon that state of mind. But also, reverie is central to the spectator's engagement with art, whether or not the particular work in question is itself expressive of the artist's reverie. For reverie is the process by which we come to find our own minds on delicate and uncertain topics.

What do you do with something when you are in love with it? 'Love is expressed,' proposed the psychoanalyst Wilfred Bion, 'by reverie.' Reverie is a way of holding something in your mind, caressing it, so to speak, with a succession of thoughts. Imagine you are enjoying being at home on a November night and you are struck by a sense of loving your warm, comfortable sitting room. It is nice to think of the cold, wet window behind the curtains; this contrastive, imagined sensation bolsters the appreciation of the comfort inside. Reverie makes the present moment richer. But the thought may contain an expansive impulse: beyond the window the dark leaves of the trees in the street are glistening; the lamps catch strings of raindrops; the gutters become little dark streams. The thought expands to flesh-out the initial vague sense of the world outside the window.

If the reverie is sustained it might develop in this way, as suggested in a short story by Katherine Mansfield. I imagine myself standing outside, feeling the rain on my face, hearing the different sounds as the rain falls on roofs, pavement and leaves. Or I imagine myself arriving in a foreign city on a similar night, aware of the dark, wide boulevard and iron balconies, dashing into the bright lobby of a hotel. The series of thoughts holds on to a momentary affection for this evening; it is transformed from a

fleeting, barely noticeable frisson into a sustained and identifiable attachment. The psychological holding-place for love is the expansive series of thoughts and feelings called reverie.

Imagination is born of reverie, and has certain things in common with it, but imagination is sometimes a more deliberate and less directly personal form of mental activity. And it is into this related but slightly different field that we now enter. We often think of imagination in terms of the capacity to summon up images of things we have not experienced: What would it be like to . . . ; What would happen if . . . ? But there is another sense of the word 'imagination' which signals a constructive capacity to see different ways in which things can be put together. To illustrate this kind of imagination let us go back to Siena and the Palazzo Tolomei (plate 15) which we considered right at the start of this chapter. What does it mean to look imaginatively at this building?

Looking at the first row of gothic arches, we can see them as a series of individual piercings in the wall, thus with a corresponding sense of the wall continuing seamlessly below, between and above them; the continuous wall is seen as having holes in it. But we can also see these windows as a linked series – which is easy if we let our eyes run along the two connecting courses of tiles which project from the building and cast horizontal lines of shadow right across the façade. Now the front appears as a set of layers resting one on the other. Neither of these ways (holes or layers) is the 'right' way to see the building – it invites both ways of seeing it – but it takes imagination to see the options. When they are both seen the visual dynamism of the building is more clearly possessed by the spectator. There is a balance of horizontal and vertical forces which makes the palazzo at once restful and lively, massive yet vital.

Imagination is an expansive faculty: it seeks out elements in the visual world with which to work, floating over the surface of the building, finding opportunities to pull things together. We might be struck by the proportion of blank, solid wall to window openings: above the principal row of windows there seems to be a huge expanse of masonry. But the windows with their pointed arches institute a virtual upward motion. Static, in fact, they appear to require the space above to accommodate their upward thrust; the stone above looks spacious rather than oppressive. In other words, imagination, here, both latches on to an architectural difficulty (too much blank wall) and perceives the felicitous handling of that very same feature (spaciousness which allows for virtual motion).

Or look at the proportions of the façade as a whole (no longer quite authentic: originally the palazzo was capped by battlements, long since replaced by more peaceable tiled eaves). At first we take in the three main divisions and note the ordered diminution in scale as we ascend – this helps to increase the apparent height of the building since it exaggerates the sense of distance. As we dwell on the details, the proportions become increasingly complex and, in imagination, we can link different elements in novel ways. Each main stage is subdivided (in the lowest by a row of heavy protrusions) so that the possibilities of relating part to part are enriched. We can couple the top of one portion with the lower part of another; we can see a different rhythm of ratios, each bar now having a stronger and a weaker beat (so to speak). And we note too how the principal row of windows is evenly spaced, except that at the ends the architect has allowed for a thicker mass of walls to prevent the horizontal emphasis being too great and causing the building to look less strong.

There is a difference between being able to see what is pointed

out by another once it has been indicated and being able oneself to originate ways of seeing. Imagination contributes to perceptual originality by elaborating hints and working with tentative suggestions which might easily be passed over and remain undeveloped. A mark of constructive criticism is the capacity to provide developed and articulate versions of embryonic response. Of course, 'original' here does not imply 'quirky' or even 'unique'. One person who approaches this building with an original imagination may very well end up coming to see it in a similar way to another original spectator.

Imagination need not rest with the rather formal features of proportion we have so far been discussing. For example, feeling slightly hot and tired (as one often does wandering around even the most beautiful cities), we may become more sensitive to the intimation of cool seclusion within the palazzo. Our expansive thoughts might attach to the high main gateway – vaguely reminiscent of an arch in a shaded Islamic courtyard – enabling us to feel the great walls as protective against the heat, as retaining in their massiveness a residual, and welcome, freshness.

In the absence of such benign thoughts the scale and solidity can seem overwhelming. Rather than being merely grand and old, it now offers, in the light of imaginative perception, an attractive (and unanticipated) impression of seclusion and relief. We saw how the imaginative attention paid to proportion brought to our eyes an impression of vitality as well as strength. And this allows the building to take on the appearance of vigour and controlled energy, rather than simply that of solidity and permanence. Noticing these slight differences – which we can when we approach the building with an imaginative eye – opens up a new world of attachment; something which could easily seem merely a forbidding monument becomes an object of

attachment. It is free-floating constructive attention which seeks out and discovers these possibilities. It is not that the eye knows in advance what to look for. On the contrary, like a good listener, the good looker doesn't presuppose that the object fits a pre-given scheme, but seeks to make the most of what is there.

Seeing for oneself, which imagination and reverie encourage, is not merely convenient (there isn't always a helpful guide to hand). Seeing something for oneself helps to make the experience matter personally. From an austerely rational point of view, the difference of genesis (seeing for yourself or having something pointed out by another) ought not to make any difference. After all, don't you end up with the same perception? But we know perfectly well that in many areas of existence personal discoveries have a savour and intimacy which is rarely matched by what we learn from others. Even though we need others to point out some things, it is a loss if they don't leave room for our own discoveries. The value of a personal discovery lies in the fact that not only do we arrive at a helpful conclusion, but that we have experience of how the conclusion was reached. We gain acquaintance with the process of coming to see. And this gives us increased confidence in all our future dealings with works of art.

This thought sheds some light on a paradox we have already encountered: someone who knows a great deal about art might not be particularly enamoured of it – their knowledge can be cold. This is all too probable if their understanding is derived only from the perceptions of others. It is ironic that even the most perceptive remarks about art can be unhelpful if we hear them too soon and they get in the way of our own responses. Their best role is to give refinement to, and a point of comparison for, our own well-developed style of looking.

*

The question with which this chapter opened can now be responded to. After describing the brute visual fact of just seeing that the palazzo is there, the question of what other kinds of visual experience we might have of it, and why these might be longer coming, arose. We have now seen the ways in which we can, as it were, visually digest the building – slow reverie and constructive imagination are the mental counterparts of a bodily process, a process in which assimilation and nourishment take place. It takes time for associated thoughts and feelings to enter into the visual process and it takes time for imagination to view the relations between different elements of the work. These are processes which do not happen automatically (they are not mandatory reactions); they require cultivation and sometimes effort. But it is in these windings of visual digestion that we come to take possession of the object we contemplate.

Reverie and imagination are not idle play – they provide a route by which our intimate concerns come to engage with what we see. And while they do not require that we bring prior learning to bear, they rely upon our willingness to pass time in a special way with the objects we encounter.

There is a catch, however. The personal quality of reverie – the way it turns us in on ourselves, the way we follow a highly individual train of association – suggests a serious problem when it comes to mobilizing this resource in the process of appreciation. For appreciation requires that we grasp the qualities of the object, while reverie may take us away from it.

Thinking again about *Autumn Sunshine*, hearing that the painting is by Walton, I may find myself thinking of *The Waltons* – the television programme about an enormous and highly moral family who run a sawmill in the American South during the Depression. I start to see the picture in this light: I can almost hear

the pick-up truck jolting along a lane just out of sight and the strong Southern voices calling out to the figure under the trees. Whatever charm I find in this, it none the less distances me from the picture. The painter was good at capturing the quality of light in a small field – and I'm not paying attention to that. In other words, reverie – as the name suggests – has a way of wandering off from the original stimulus and taking one off somewhere entirely different.

To put the problem in a more philosophical fashion: my reverie or imaginative elaborations may get in the way of understanding. In the main body of this chapter I have looked at ways in which they provide an indispensable resource for deepening our encounter with works of art, but this does not show that they always and necessarily make such a positive contribution. Reverie and imagination are not answerable to history, for example, but appreciation and understanding are. I may be charmed by the humility of placing an easy wide-eaved roof, like a veranda, on an otherwise martial building like the Palazzo Tolomei. But then I am at odds with history, for as we know the palazzo originally had battlements. This does not show that reverie is illegitimate in the presence of artworks, or that the expansive force of imagination is to be dispensed with. But such examples do show that we may have to operate with more than one concern at once. We may need to work with information as well as reverie.

The powers of reverie and imagination need to be harnessed when looking at works of art. They are important because they provide such a major way in which we uncover the internal structure of works of art and develop personal relations with them. But these expansive ways need to be interleaved with the way of scrutiny: our devotion to the work as it really is. And it is to this business that we now turn.

5

Contemplation

The process of contemplation complements that of reverie; whereas reverie follows a personal trajectory of associations, contemplation is given over to scrutiny of what is there to be seen. It is, literally, spending time with the object – not just time around it or standing before it, but time devoted to looking at it. 'Contemplation' has an august history used in Western thought to describe the mind's approach to God and in Eastern philosophy to characterize the highest state of existence, but it remains – even in more modest uses – an obscure term. What goes on when we contemplate something, what are we actually doing?

The process of perceptual contemplation of an object has, classically, five aspects:

1. Animadversion: noticing details.
2. Concursus: seeing relations between parts.
3. Hololepsis: seizing the whole as the whole.
4. The lingering caress.
5. Catalepsis: mutual absorption.

(This is similar to the route by which many people fall in love.)

1. Animadversion

Spending time with a work of art is central to developing a personal relationship with it, but we do not always find it simple to give works this time. From an anthropological point of view this is unsurprising: the human perceptual system is not particularly well adapted to prolonged observation of flat, coloured surfaces or stationary masses of stone; medium-sized animals moving through the shrubbery are more our evolutionary *métier*. So when we find ourselves standing alone in front of a painting – Delatour's pastel portrait, *The Présidente de Rieux Dressed for a Ball* (plate 17), say – time can seem to drag. A whole minute can seem like a long time to stare at the picture; even then we might not notice that the woman is holding a black mask. (How many visitors to the Louvre notice that the Mona Lisa doesn't have eyebrows?) It is not only that the angle of vision makes the mask unobtrusive: we just don't expect a respectably dressed, grey-haired woman to carry such a thing (and when we see an eye we tend to take a brow for granted). The perceptual trick of taking certain things for granted – the principle of omission which allows us to concentrate on what is immediately salient – works beautifully for most of our observational needs; when it comes to the arts, however, it is a problematic habit.

It takes time to become visually aware of all the elements of Delatour's picture: to notice the slight reflections in the mirror, to attend to the pattern on the back of the chair, to see the arm of the chair, to follow the folds in the dress. With respect to paintings, as with most things, the capacity to notice detail responds to cultivation: the more you try, the better you become at it.

The import of detail for overall effect is not confined to

painting or the fine arts. We can be acutely sensitive to the effect of a well-chosen pair of earrings, the wrong colour of shoes, an injudicious tie or the slight twist of the torso in someone's stride. We are used to noticing detail within certain fields: our sensitivity is specialized in practice. Most people have more dress sense than picture sense, but perhaps the two do not really differ in principle.

Contemplation – in its initial aspect of animadversion – is time spent noticing details; that is, the process of becoming visually aware of parts of the picture which our habitual rapid scanning tends to gloss over. This is a process which sometimes requires conscious effort, we feel we are literally turning our attention on to different parts of the canvas and saying to ourselves: Well now, what is actually *there*? ·

It seems to be the pleasure of isolating objects and noticing detail which motivates certain features of early oil painting. A very accomplished follower of the early sixteenth-century Antwerp painter Quentin Massys (or perhaps Massys himself) in his picture *St Luke Painting the Virgin and Child* (plate 18) devotes great attention to an array of studio objects. Jars, jugs, books, caskets and brushes as well as larger items (easel, table, bulbous mirror) and the setting (floor tiles, panelling) are, for him, so many opportunities to dwell on the form of visible objects, to set them securely at a definite point in space, to pay homage to their individual appearance. It is this which gives the painting its unnatural clarity and precision. We do not normally notice anything like as much of our surroundings, and each thing is attended to with equal scrutiny – which is quite foreign to our normal habits of perception.

In the history of painting, however, loving attention paid to individual objects – and hence the treatment of individual

17. Delatour, *The Présidente de Rieux Dressed for a Ball*. Two minutes can seem like a long time to look at a picture.

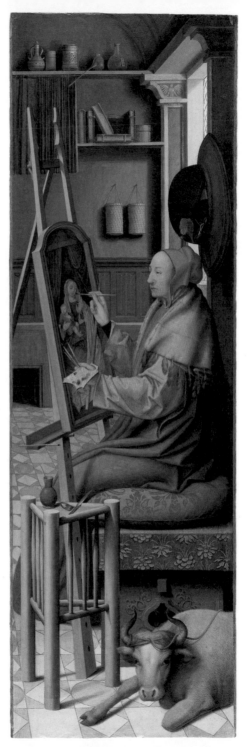

18. Follower of Massys, *St Luke Painting the Virgin and Child*. Visual contemplation involves seeing each individual object just as it is. The picture testifies to the love of that kind of looking.

portions of a picture as almost separable one from the other – quickly came into contact with a larger, and not easily reconciled, ambition. And this further ambition corresponds to a further aspect of contemplation.

2. Concursus

One of the great ideals of composition in painting has it that every element should be justified in terms of the whole – to call this a great ideal is not to insist that every great painting aspires to it (which would obviously be false). When it does apply, however, you should be able to look at any detail and ask 'Why is that there?' and get a good answer. We can trace, in such a painting, the task which every least element has to perform with respect to the good of the whole.

Let us look at David Wilkie's early masterpiece *The Letter of Introduction* (plate 19). The picture shows an elderly and successful man deliberating his response to a letter of recommendation which the young man has presented, and through which – we may suppose – he hopes to solicit the older man's benevolence. This much the title, a glance at the picture and a smattering of social history will tell us. What of the details of the picture? Take the crooked leg of the dog, what is the pictorial significance of this detail – what task does it perform?

The dog turns with a curious and friendly air towards the youth. The half-raised paw looks like the beginning of a more expansive welcome, but the movement is hesitant. The animal, none the less, indicates goodwill and welcome more freely than its master. The raised paw enters into the psychological situation. But the very *naiveté* and trust of the dog puts a more sophisti-

cated gloss on the matter. The dog can be affectionate but cannot take responsibility; it can be friendly but cannot grasp the difficulties of a young man of unproven merit embarking on a career and in need of support. The contrast between natural friendliness and socially acquired caution makes more poignant the human condition in which we cannot have the simple trust of the dog because we are forced to reflect upon experience. This is to consider the role of the dog and its gesture in terms of psychological nuance, where it serves, as it were, as a revealing secondary plot. We can also consider it in terms of formal composition. The mobility of the animal – the raised paw is essential to creating this effect – helps bring out the solidity of the sitting man and is one of a number of elements which lighten the picture. Others include the delicate arch above the safe, the decorative vase and the extensive 'scumbling' (working an opaque layer of oil paint over a lower layer, which is of a different colour or tone, in such a way that the lower paint is not completely obscured, so creating an uneven, broken effect). The theme of red – of which we find touches in the sealing wax, on the writing tray and on the binding of a book – also serves as a foil to the predominantly subdued colouring of the picture which is mostly brown, grey and buff.

The paw, if we follow the line of its axis, extends up to the young man. It is also, very nearly, parallel to the master's right leg, and that, in turn, is linked diagonally with his other leg. The paw thus has affiliations (visual echoes) on both sides of the picture. This is important because the visual relation between the two men was clearly a major artistic problem facing the painter.

Wilkie has made the figures very distinct, partly by keeping the figures well apart and avoiding any direct gesture from one to the other. He also achieves this partly by a series of contrasts between the two figures: standing, sitting; eyes downcast, alert;

19. Wilkie, *The Letter of Introduction*. Wilkie has to keep the supplicant well apart from the patron but still manages to give visual intensity to their encounter.

20. Schema of *The Letter of Introduction*. Indicates the key visual forces at play in the picture. This is what creates cohesion despite the distance between the two principal figures.

grey coat, light buff coat; dark hair, white cap. These are good ways of expressing their very different situation. But at the same time the painter needs to give a visual analogue of the intensity of the exchange; the picture therefore requires more subtle ways of keeping these men in visual relation to each other. The dog, and especially its raised paw, is one of the means he pursues to hold the two figures (apparently so distanced) in a tight visual relation. As we see the pictorial point of the paw, we fuse the two sides of the painting: the paw takes up the rhythm of the gentlemen's legs, but also leads our eyes up to the youth.

There are other devices working to the same end. Noticing these is an exercise in seeing the visual tasks carried out by apparently minor details. What's the point of the decorated vase, for example? Does it matter that the old man is sitting so far to one side of his chair that we are given a view of almost the whole sweep of the top of its back? The vase is carefully rendered (in a picture in which many objects are left rather vague), and its strong pattern makes it stand out from its surroundings. Initially this might seem odd because it draws the eye a little unusually down into one corner of the picture. But beyond this first response, its distinctiveness makes us see it in relation to the only other comparably 'strong' and concentrated portions of the painting: the gentleman's head and the youth's head. When we focus on any particular part of a picture we remain peripherally aware of the rest of the painting, and the pictorial elements we continue to be aware of enter into relations with whatever it is we are concentrating on. To say that one portion is more decorative, more incisive and bold than others is also to say that it holds its place more vigorously in our peripheral attention. As we look intently at the seated man's eyes we remain aware of the youth's head and of the vase: the two other parts which most insistently call for attention.

The visual links are made stronger by parallel articulations within each. The final curve of the back of the chair (halfway between the heads) emphasizes the line between them. The elegant line of the back of the chair floats out towards the youth and is related to the curve of the dog's back. In a picture of strong rectilinear order, these curves are distinctively light and pleasant. The line of the chair-back helps bring the man's eyes to our attention (as does his white cap), then floats us in the direction of the youth. At the same time, the strong nexus where the desk meets the gentleman's elbow reinforces the connection between his head and the vase because it lies directly between them and helps the eye travel from one to the other. Thus we see the gentleman's head subject to two external visual forces – the head of the youth and the sumptuous vase: a visual analogy of his indecision. Plate 20 shows these schematic relations.

Concursus, then, involves seeing together many individual elements of the picture. Its pay-off comes in an enrichment of visual significance, of meaning. Scrutiny of a work of art frequently involves a rhythm of attention to individual parts and to the relations between those parts. This rhythm is required by art and it is also native to the perceiving mind. In fact we can see here how works of art respect and play up to the natural character of exploratory and synthetic attention; it is a native resource of the mind which we can bring into active, and developed, service in the engagement with works of art and which artists usually presuppose we will bring into service.

The ambition of concursive attention – the ambition of drawing things together and seeing them in relation to each other – naturally expands to incorporate more and more elements of the work; its logical maximum reveals a further aspect of contemplation, which we consider in the next section.

3. Hololepsis

To seize a work as a whole – as a single complete entity – is an achievement of contemplation which stands at the opposite end of the spectrum from fastening upon it detail by detail. These postures of attention are not opposed but they are so different that in practice the pursuit of one can lead to the neglect of the other.

That works of art call for holistic attention derives from a basic principle of creativity. We can come to understand the kind of attention we need to cultivate by thinking about this principle. It is a maxim of art – an acknowledgement of the alchemy of artistry and of the resistance of the master-work to reductive analysis – that the whole is greater than the sum of its parts. What is this extra something (the factor X) which emerges when parts are brought together with artistry in a way which distinguishes the wholeness of a work of art from a mere aggregate of separate items? How does an aesthetic whole differ from a heap? This was the question which particularly occupied Aristotle in his *Poetics*, the first technical treatise on composition.

Purely practical considerations aside, there is no sense in which a heap can be complete. A slag heap (or, to take other examples of the heap-principle, a shaggy-dog story or a doodle) might reach the regulated maximum size (or the limits of polite endurance, or the edge of the paper), but nothing in its own nature determines this maximum. With examples like these squarely in view, sense appears at last in Aristotle's otherwise strange pronouncement – that a successful drama must have a beginning, a middle and an end (a principle which, with due adaptation, extends to all the arts). Strange, because to plain understanding a play can hardly

fail to have these features, unless it is manifestly unfinished. How can possession of such banal features be adduced as evidence of artistic excellence or be recommended, as they are by Aristotle, to the aspiring dramatist? (No one would qualify as a tennis coach on the strength of recommending players to get the ball over the net – you can't play at all unless you can do this.)

In fact, Aristotle is on about something much more interesting than might at first seem to be the case. His concern is with the way in which features of the work can be seen to have internal qualities of development – a development which can be seen to start and can reach a conclusion. When the end does come, it has the character of finishing something rather than of being an arbitrary halt. The end, as it were, makes sense in relation to what has come before. Equally, the opening is not just a chance start but seizes the origin of the process to be followed through. There is thus an important point to starting here and ending there: a point understandable with respect to what happens in between. What goes in the middle isn't so much stuffing but a genuine progress from one to the other.

This principle of internal justification can be pursued with more or less rigour, leaving more or less unjustified fat on the structure. The leanest version is given in the old formula of beauty (from Alberti who got it from Plotinus): 'The beautiful is that from which nothing can be taken away and to which nothing can be added but for the worse.' Irrespective of its adequacy as a definition of that most elusive of notions, beauty, this adage does serve to characterize in its maximum degree the kind of unity and completeness Aristotle draws attention to. As with any aesthetic principle, a number of questions stand in the wings: How does it actually operate in particular cases and why should we value an achievement of that sort? What is unity or

completion to me? But let them wait a little longer until we have drawn out the savour of the principle in consideration of an individual case.

As a perfect example of such perfection consider Palladio's most famous Villa Rotonda, built for entertainment in the 1560s, which sits on a hillock near Vicenza, then as now surrounded by olive groves and fertile fields (plate 21). It is a compact, square building with four gracious and identical porticos, each at the head of a charming flight of steps. It is among the most beautifully proportioned of buildings. If the flight of steps were higher, the columns would appear too slight; if the columns were larger the steps would look less noble. If the porticos were wider, the flanks would be too narrow, and so on. But such interplay is not limited to proportion. A little more pristine, and the formality of the building would be oppressive. The terracotta roof tiles and now the patina of age on the crumbling plaster of the walls have an attractive insouciance – an example of how a building may be improved (to my taste) by what its original possessor would have seen as an imperfection. Were the main body a little more ornate, the surrounding statuary would lose its role as contrastive foil. Or consider the side arches which terminate the porticos – why arches, why not leave them entirely open or fill them in? But blocked, the building would become heavy, its centralizing force would be disrupted, we would lose the suggestive glimpse of further columns which the openings afford. Entirely open and the building would lose its solidity, and the porticos would seem to detach themselves from the main block. Each element and aspect appears necessary, when considered in relation to the other. These mutual relations of aesthetic necessity exist only when we consider the building as a whole.

Hololepsis yields an archetype of completeness and coherent

explanation – thus responding to two of the great aims of mental activity. The contemplation of art of this kind and in this way can satisfy yearnings which the world generally frustrates. The world frequently springs the unexpected and sprawls in seemingly meaningless disorder. The prestige of systems of total explanation – religious, scientific, historical, philosophic – indicates a general need to grasp the world as a coherent whole in the face of its apparent confusion. A work of hololeptic art has the advantage over some of these systems in that its coherence does not rest upon falsehood; it has the advantage over others that what it offers is visible and palpable rather than abstract. Yet, of course, the price a work of art pays for this is that its completeness is bounded by its own small physical extent. It answers a yearning, but only in a restricted arena. Hololeptic contemplation, thus, links the experience of art to the wider demands of reflective life and suggests how, to a certain kind of person, the experience of art could be of prime private importance.

4. The Lingering Caress

Why do we return to works of art – why look again at something you have already seen? The question becomes a source of embarrassment for certain conceptions of our engagement with art. If visual discovery, or relating a work to its historical context, or gleaning social information, exhausted our concerns with art, then it would be bizarre to return to a work once these tasks were complete. It is sometimes suggested that part of what is fascinating about the Impressionists is the way they reflect the changing society of their time: the extension of railway lines into the areas around Paris, the fashion for beach holidays. But we could study

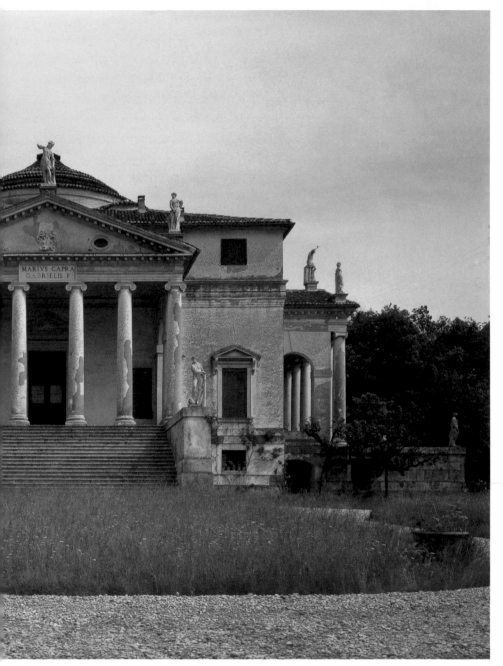

21. Palladio, Villa Rotonda, Vicenza. 'Nothing could be added or taken away but for the worse,' except, perhaps, that slight dilapidation deepens its appeal.

these things far more efficiently and seriously by consulting historical studies and the newspapers of the day. The fact that we don't suggest (to me) that we're not really interested in such things and that they come to be cited only because there is pressure to say something rather than nothing about the appeal of the works, and because of the real but misplaced prestige which facts of this kind possess. Such approaches leave us stranded after the first moment of recognition. 'Oh, there's the suburban train, how fascinating' – but we can't keep on being fascinated by the mere fact that it's a picture of an early suburban train we're looking at. Who could care to return to that? But we do return.

Contemplation is an open-ended process; it can get broken off but it can't be completed. When we savour something we hold our attention upon it; and that holding can be extended as long as we wish, or until we become jaded. When we savour the scent of a rose or the texture of an oyster, the thing attended to is the sensory experience itself: we concentrate on the stimulation afforded to our sensory organs. But we can savour more complex states too: hololeptic attention can be held on to – having grasped the object as a whole we stay with this experience; holding on to our perceptual holding of the object.

If only because we are so used to the idea of evaluating ourselves in terms of accomplishments and achievements, it can seem strange to treat lingering as a virtue. When we linger, nothing gets achieved, nothing gets finished – on the contrary satisfaction is taken in spinning out our engagement with the object. Put like this we can see what cruder accounts of interest in painting miss: they cannot say much about why anyone would want to spin out the kind of engagement they describe.

In private life, as we know, there are two kinds of caress: of the lover and of the partner (at their sweetest, dual aspects of a

single person). It is the same with art. The excitement of the first moments, when we feel that we are really getting close to a picture or a building, can develop into a comfortable life with it: one in which we take satisfaction in just being quietly around this special thing whose character we know well and whose presence makes us feel at ease.

5. Catalepsis

When we keep our attention fixed upon an object which attracts us, two things tend to happen: we get absorbed in the object and the object gets absorbed into us. In Western tradition, contemplation is seen as good in two ways. On the one hand, it is a state of mind (or soul) which is good in itself – one of contentment and concentration – which puts thought and feeling into harmonious accord. With luck we are so taken up with the object of contemplation and the process of devoting ourselves to it that other more distressing thoughts are squeezed out. We gain relief from anxiety and egoism. One of the things which has traditionally been valued in contemplation is, thus, its ability to liberate us – if only temporarily – from the general round of self-centredness: the multitude of desires, concerns and worries which occupy large parts of our mental space. These virtues, of course, depend upon the general character of contemplation more than the specific qualities of the thing attended to.

On the other hand, the quality and virtue of contemplation may depend also upon what it is we are giving ourselves over to. We can visually contemplate anything which we can see; but do some objects reward this kind of attention more than others? The belief that it makes a difference what you contemplate relies

upon the assumption that what you contemplate somehow gets inside you; contemplation is the spiritual analogue of eating. The possible mental absorption of what we devote our attention to is reflected in two prominent debates: those concerning the didactic function of art (its capacity to teach us) and censorship (its capacity to corrupt).

Curiously, these debates pull against each other. Contemporary advocates of extensive censorship argue that images (of the degradation of women, the charm of violence) promote unhealthy attitudes. But on the other side, the ancient ideal of art as a means to moral instruction seems exceedingly optimistic. Getting people to change their ways ('stop eating and drinking too much, don't lust after money') requires a great deal more than getting them to look at a few refined pictures of Silenus (demi-god of overindulgence) looking ridiculous, or of the ascetic Diogenes spurning the gifts of Alexander the Great. This suggests that it is actually very difficult for contemplation to make a difference to someone's life – for visual images to have an impact upon practical attitudes and habits. This conclusion is at odds with the strong demand for censorship, which seems to suppose that images very easily and extensively influence attitudes and behaviour. A solution to this opposition of thoughts lies in the fact that absorption of the thing contemplated (for good or ill) requires much else to be in place. Thus an ordinary decent person is not going to be corrupted by a violent or degrading image because there are so many grounds and reasons why they do not behave in such a fashion, and a picture, no matter how seductively painted, is not going to be able to destroy all of these at a stroke. But someone already pretty keen on violence and depredation might find encouragement. Equally, someone entirely given over to feasting, luxury and conquering the world is not

going to become a modest and frugal citizen just because they see a picture which advances these virtues. But someone already impressed by stoic self-sufficiency or plain living might take heart from the contemplation of such works.

What all this suggests is that absorption – taking something inside so that it is retained and has influence upon our reflections and habits – is not a quick or simple process. It depends upon what is already there within us: our pre-formed digestive capacity, our already existing manner of feeling and behaving. This has one significant but perhaps unsuspected consequence: we cannot respond equally well to all kinds of art. The modern museum situation often encourages us to take all periods and styles with equal seriousness. But this defies the reality for the individual constitution; we get most from works of art which have most to offer us, but that is a function not only of the works themselves but of our own characters and capacities.

Sustained attention – in which we start to make a work our own – is a cultural and personal achievement. At every turn the practical business of living and the internal sources of dissipation (the urge to break off, have a snack, a cigarette; the tendency to break off when anything, which is not practically necessary, is difficult) bear in upon us and rupture concentration before we have come to close quarters with the thing we are giving our attention to. One of the virtues of the arts is that they can foster this kind of attention in a pleasant way.

The process of contemplation – in the various aspects we have considered – provides a description of one major way in which we can engage with works of art. It stresses the devotion of visual attention to the work: the scrutiny of the surface; the searching out of visual links between parts; the savouring of what we come

to see. In this respect, contemplation stands in a dialectical relation to reverie. A problem with reverie is its tendency to spin off in a direction which takes our attention away from the work, but it has the virtue of getting material into play, of bringing our responses to the surface, giving us a chance to find out what our thoughts and feelings are. But contemplation which is anchored in attention to the object takes us back from reverie to the object only, no doubt, to take off in further reveries. Slowly we get to know the work and our reactions to it.

The play of reverie and contemplation is interesting and worthwhile in its own right – it describes a manner of attention relatively independent of concern with what is focused upon. This is reflected in the way in which an otherwise quite trivial object – a chipped bathroom tile, a paper clip – can be taken up in this complex engagement. And when contemplation is pursued for its own sake, it is often precisely such uninviting objects which are recommended.

Works of visual art characteristically invite this dual mode of attention, but also invite it to focus upon a particular (and sometimes quite elaborate) subject-matter: a beach scene; the sun setting over the mountains. In the case of a building, specific functions need to be taken into account too; not only do we see the building as belonging to a general functional type (church, railway station, house) but concern with function enters at a much more specific level: these are walls, roofs, places to sit, entrances which we are looking at, contemplating and having reveries about. Our sense of the worthwhileness of the whole episode of giving attention is liable to be linked to our sense of the importance of the thing we are engaging with. (Consider a parallel with listening: one can listen with more or less devoted attention to anything; but it makes sense to give one's best atten-

tion to the most important subject and there is a feeling of waste when we devote efforts to things which, upon reflection, seem paltry.)

But here an obvious complication arises. With respect to art, it is not always easy to say, in advance, what is an important thing and what isn't. A bowl of cherries may not sound like an earth-shattering subject-matter, but when treated by Chardin, for example, it can seem profound. This is a well-discussed problem with respect to painting, but it occurs in connection with architecture as well. A doorway may seem to be the most ordinary kind of thing, hardly worth a moment's notice – its very function invites one to pass through rather than to linger. But if the doorway has been formed with the skill and imagination evident in the one created for the Palazzo Ducale in Urbino (plate 22), our sense of what a doorway can be might itself change.

The door frame is carved with trophies of war, giving a triumphal air; but the graciousness of the proportions, the finesse of the craftsmanship and the elegant lines of the inlaid door-panels sound a distinctly non-martial note. The doorway is august, certainly, but also inviting – the inlaid foliage at the base of the doors (it's rather high, giving a feeling of lightness) is reminiscent of the soft tread of grass; the flowers and garlands, the fountains and the engaging cherubs suggest repose and pleasure. Perhaps the doorway itself indicates a passage in life between achievement and enjoyment, standing as it does at the head of the staircase of honour. The dramatic differences of texture between the plain surrounding wall, the carved stone of the frame and the inlay of the doors help to draw attention to the doors themselves, making them conspicuous. Although we know they can be opened, they have a solid appearance: they are a substantial barrier when closed, hence their opening, when they do open, is a real event.

22. Doorway, Palazzo Ducale, Urbino. Teaches us what a door is, just as
Cézanne or Chardin teach us what an apple is.

The object of our reverie and contemplation in such a case is not simply a door, but this specific and particular door – this door formed and decorated as it is. But seeing it as a particular object occurs as we give our attention to it; it reveals its character as we devote our resources to seeing it.

Consideration of reverie and contemplation – as they come into play in engagement with individual works of art – leads us to yet another issue. That is, our sense of the significance and interest – in short, the value – of the thing to which we give our attention. We have seen, negatively, that we cannot always know in advance what the significance of the object is, for that is revealed in the serious attention we give it. But that is merely a negative point, it doesn't tell us how objects do come to seem important. To pursue this seam we must move on to reflect upon a crucial way in which objects come to matter to us and seem valuable, namely, the investment we make in them.

Investment

'What do you need to bring from life?' 'How much emotional baggage, how many convictions can you safely take with you into a gallery or around a building?' This is worth asking, if only because our emotional baggage and convictions usually play an important part in forming our interests and attachments.

Nevertheless, 'travel light' was the recommendation of the Bloomsbury writer and painter Clive Bell, giving voice to a central tenet of Formalism. 'We need to bring nothing with us from life, no knowledge of its ideas and affairs.' Bell was not, by spectacular oversight, unaware that artists in all media have made continuous call upon our knowledge of, and interest in, life. He knew that when artists painted Liberty leading the People or the pots and pans in their kitchens they expected people to have some concern with politics or domestic life. If we were with him looking at *The Holy Family on the Steps* (plate 23) painted in 1648 by Poussin, Bell would readily acknowledge that the painter expected us to be interested in such things as classical architecture, plants and the central figures and doctrines of Christianity.

Bell would not dispute that Poussin worked with these concerns, only he would insist that these were not where the strength of the painting lay. By analogy, he could cheerfully admit that

there was soda with his whisky, without being led to doubt that the spirit alone gave the drink its kick. Spatial organization was, he believed, the artistic equivalent of single malt; this is where the work gets its potency. And in attending to that, you wouldn't need to be concerned about any issues from the rest of life. So Bell's theory goes.

There is an important corrective emphasis in this proposal. Frustrated by people who look at pictures only in terms of their narrative or psychological content (a temptation which comes easily to those whose education is more literary than visual), he rightly reacts by encouraging attention to formal aspects of the work. Forget about the religious meaning, enjoy geometry – look at how curve answers to curve, how they create a foil for the background grid of horizontal and vertical lines; feel the beautiful evocation of crisp three-dimensional organization with its twin movements of ascension and recession; take pleasure in the perfect asymmetrical balance – see how the left-hand column is matched by the lower pedestal (garnished with Joseph's foot). When we start looking in this vein, more and more felicitous details and harmonious relations strike the eye – much of which would be missed if we had contented ourselves with pondering the narrative and symbolic content: the flight of the Holy Family into Egypt as a metaphor for the travails of the true Church in modern times, and so forth.

Bell was also concerned to advocate the work of Cézanne and the Post-Impressionists to spectators who, up till then, would have been more at home with the work of Tintoretto or Turner. By comparison with the old (and Victorian) masters, the modern painters were barely, or not at all, interested in presenting narrative content. But Bell could make apparent an unexpected continuity of artistic intent by encouraging people to see the old

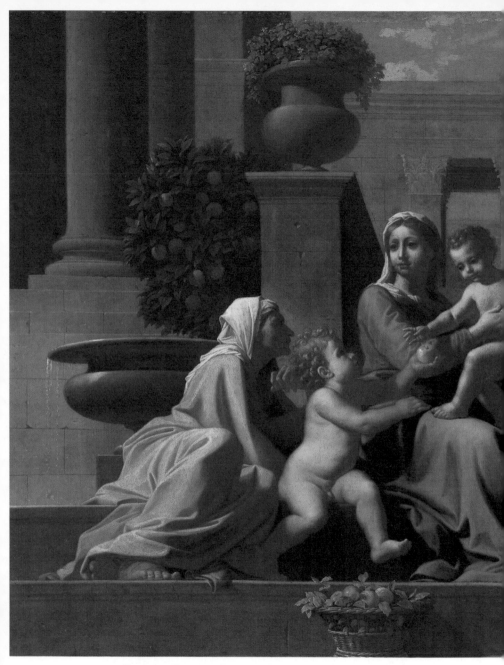

23. Poussin, *The Holy Family on the Steps*. Form and content in perfect harmony. St Joseph's support of Mary is both a feature of the composition and part of the religious meaning of the picture. A visual refutation of Formalism.

masters in abstraction from subject-matter. If you can see with pleasure the pictorial architecture of a Poussin or a Titian, you are well prepared to respond to the logical structure of a Cézanne landscape; whereas if you are used to thinking about paintings primarily in terms of the stories they tell or the moral message they encode then Cézanne will appear rather dull.

These two recommendations – look at the non-narrative aspects of the picture and see the continuity between the old masters and the moderns – are valuable in themselves. But Bell has an inflated conception of what is required to secure these benefits. You don't need to ignore narrative in order to see structure – you just need to avoid giving it all your attention all of the time.

Bell works with an oppositional sense of two capacities: that of attending to form and that of attending to content. You do one to the exclusion of the other, you must choose between them. In fact we bring to our engagement with painting a further and distinct capacity. This is the capacity to attend to content as it is formed and to form as it contributes to and generates content. And there are many features of paintings which require us to hold both form and content in view at once. The solemnity and poise of Mary (psychological content) coheres with the geometrical elegance of the composition (form). To enjoy this coherence and take pleasure in the way one illuminates and contributes to the other we need to be attentive to both at once. Or consider St Joseph: formally, the simple dark mass of his robed body represents a supportive base for the mother and child. But this is a psychological role too; one reinforces the other. Taking the picture more generally, there is a striking contrast between the physical complexity – the bending, folding, moving – of the human group and the smooth regularity of the architectural setting, a

contrast which is given greater prominence by the strong colour-
ing of the figures and the quiet grey of the buildings. This is a
contrast which operates both at the level of content and at the
level of form. The psychological evocations are elusive but sug-
gestive: the figures belong to a different order of things; the archi-
tecture comes to stand (we might perhaps think) for the
permanent laws ordained by God, the architect of the universe, in
the Old Testament; while the brighter figures who animate the
scene intimate the irruption of grace which is narrated in the
New Testament. But if it is hard to pin down exactly the psycho-
logical significance of the contrast between figures and settings
(and we are, frankly, speculating), we are not thereby reduced to
saying it is insignificant. We have, instead, as is quite often the
case with pictures, a visual embodiment of meaning that is hard
to translate into words, a pictorial presentation of something
ineffable. And in so far as we see the picture in this way, we are
responding to something which has both form and content and
to which we are equally in debt for the experience.

If Bell's advice (travel light) seems less than satisfactory, per-
haps we should listen to someone who holds the opposite view –
that we must never for a moment forget our outside concerns
when wandering around an architectural masterpiece or an art
gallery. When, recently, Professor Lisa Jardine suggested that *The
Rape of the Sabines*, also by Poussin (plate 24), should be taken
down from the walls of the National Gallery where it was hang-
ing on loan, she was concerned about the violence of the depicted
scene.

Contrary to the recommendation that we leave our knowledge
of the world with our umbrellas and coats in the cloakroom,
Professor Jardine was clearly stalking the picture rooms bristling
with worldly concerns: foremost among these is an entirely sane

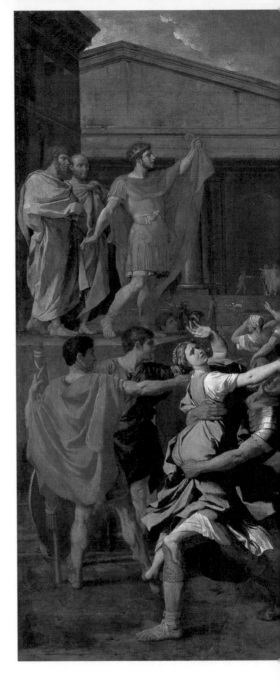

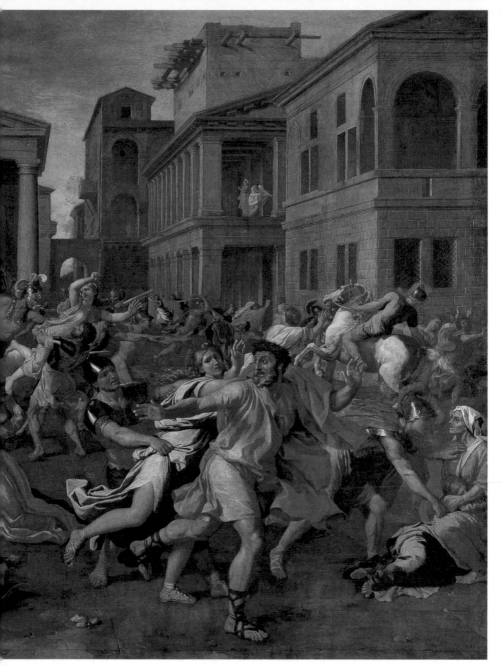

24. Poussin, *The Rape of the Sabines*. Such pictures tend to be liked by sweet-natured people.

horror of violence. This is a worldly concern no one should be without, but its implications for the enjoyment of art should make one pause. Should we take down all the battle scenes, all the murders, crucifixions? And if the principle of exclusion – offence against current wise attitudes – is taken seriously, shouldn't we also get rid of the pictures which glorify rather horrible people (many Renaissance portraits), present women in subordinate positions (many Dutch genre pictures) or celebrate the frivolous pleasure of the idle rich (much eighteenth-century French painting), for none of these comes up to the standards of conduct which we rightly insist upon today. But before we begin burning the canvases, we might pause to reflect upon an awkward fact: that the worst offenders – the people who go most regularly to view these images and who place the highest value upon them – are generally peaceable, hard-working egalitarians. We might begin to wonder whether Professor Jardine has perhaps too strict a method of applying worldly concerns to art. This conclusion is supported by reflection that paintings like Poussin's *The Rape of the Sabines* do not merely show scenes of violence. That picture is also a sensitive exercise of historical imagination; it is composed and painted according to a very different set of values than those enacted by the Roman soldiers it depicts. The painting itself, as a created thing, bears witness to a love of tranquillity and seemly order, it is sensitive to individual character and to harmony. There is evidence of attentiveness to the human pain of the scene – terror, horror, anger, dejection and even pity are presented alongside brutal determination. The psychology of the picture is further complicated by the universal character which Poussin gives the scene – his presentation of it has a timeless quality which encourages us to open its reference to all times. The explosive and uncontrollable powers of passion are presented in the vigorous

chromatic sea of figures, but this movement is itself choreo-
graphed according to rational principles and contained within the
greater order of the composition as a whole.

This generates a much more complicated presentation of vio-
lence, perhaps as an elemental passion to be governed, eventu-
ally, by reason. (Poussin was notoriously rowdy in earlier life;
famously master of himself later.) Violence can be mastered, and
understood, from a larger perspective (history, art, maturity). To
cultivate such perspectives it may be necessary to consider acts of
violence very carefully, rather than to exclude them.

Whether or not this interpretation is correct – and interpreta-
tion of such a painting will always have a speculative edge to it –
it is certainly not foreign to the spirit of Poussin's art. The rigor-
ous application of the 'no violence' principle turns out, in this
case, to be like trying to peel a shallot with a pair of garden
shears. Which isn't of course, to say that there is anything wrong
with garden shears – uncompromising, unsubtle rigour might
sometimes be just what is needed. But it is not what is needed
here.

To summarize the dialectic: we cannot accept the claim (advo-
cated by Bell) that our external concerns and convictions are
irrelevant to engagement with art. But external concerns, if pur-
sued too literally, can get in the way of engaging with art; the
external interest here predominates and blinds us to everything
else going on. Thus we need to try to find some way to use our
worldly concerns and knowledge in a way which is fruitful rather
than debilitating. They cannot be applied raw. But how are we to
conceive of this more fruitful mode?

Objects for Emotions

One of the turning points in *Anna Karenina* occurs when Levin, Tolstoy's central character, rides out to survey the work on his estate one morning in early spring. Levin has passed an anguished winter following the rejection of his offer of marriage by Kitty Shcherbatsky, leaving him humiliated and cut off from the family life he longs for. He has been resentful and morose. But now,

Peacefully swinging along on his good little cob and drinking in the warm, fresh scent of the snow and the air, he rode through the wood here and there, over crumbling, sinking snow covered with dissolved tracks, and delighting in every one of his trees with their swelling buds and moss growing green again on the bark. When he came out of the wood, a vast expanse of smooth, velvety green spread before him without a single bare place or swamp and only stained here or there in the hollows with patches of melting snow.

After this, although he retains the traces of his hurt, Levin has new vigour; the crisis has passed and he is safe. The returning spring provides a visual image of something invisible: the resurgance of life in Levin. His bitter feelings melt, he has a budding concern for his future projects, he feels a warm sympathy for his labourers.

Tolstoy enriches our sense of the return of emotional life by linking it in an extended metaphor to the return of life to the land. He hints at a natural rhythm to the passing of grief – Levin's vitality was dormant, not destroyed. The couple-colour of the green expanse where patches of snow still lie in the hollows suggests a dappled spirit, in which old pains are not entirely

effaced, and which everyone can recognize as the authentic feel of recovery. This is a base theme of the novel, one which returns right at the end. In the celebrated closing soliloquy, Levin accepts that his own character will always be chequered, he will lose his temper, feel at odds with others, be impetuous and unreasonable at times, but he finds all this compatible now with an abiding satisfaction in himself and in life. Snow lingering in the hollows does not compromise the reality of spring.

It is possible to take such a sight as the cause of Levin's feelings: it is because he sees the buds and the bright fields that he feels happier. Alternatively, we might suppose that it is because he feels happier that he can take pleasure in the things he sees. An unhappy man might have found those same sights drab and irksome. ('The world wears my colour,' remarks Emerson of just this phenomenon.)

Thus feeling can stand to visual experience sometimes as consequence and sometimes as cause. But these two ways do not exhaust the options. It is, in any case, comparatively rare that external objects completely condition our inner life – that we are dragged from misery to joy by contemplation of a stretch of land, or that we project what we feel on to whatever we happen to come across – so that it becomes a blank receptacle for our passions. And in any case, neither of these options fits well with Levin's case. His regeneration did not start with his ride; it was crystallized there. It did not all of a sudden take him from gloom to joy, but it allowed a happier state of mind to emerge more fully. And he didn't just project his renewed sense of life on to the landscape, something in the landscape called out to him and enabled his response. So if it is neither cause nor consequence of his feeling, how does the experience of the landscape stand to Levin's inner life?

An emotion without an object is like a lover without a loved one (or a miser without a hoard). Feelings need objects. What do they need them for? When they are apart, the lover turns over in his mind the details of his beloved. He remembers the way she moves her elbow, how she will dart her eyes to one side, the slight raising of her upper lip; he dwells on the phrasing of her speech, her idiosyncratic ignorances (she cannot place Greenland on the map). His love lives off these details; it would be a minimalist love if it did not seep into so many of her parts, physical and moral. One of the dimensions in which an emotion can grow is in the degree of its intimate penetration of a suitable object. Love would be impoverished if the loved object could not accommodate this elaboration. A man loses his son and pours his feelings into affection for his dog; we feel sympathy and a certain pity. The dog cannot replace the child as an object of emotion, for there is in the dog so much less for the emotion to work upon and work itself into. The dog is, as it were, too small to contain all that love, and in forcing the issue the relationship is reduced in quality.

But when love finds a proper object it can flower. Over time, a long-term feeling is composed of a multitude of constituent motions of the heart and mind; the object on to which all this latches has an important role to play in shaping the constituent motions and so forming the contours of the emotion considered as a whole. Feelings have details, and it is in their details that their quality lies. The character and shape of the lover's love depends upon the myriad ways in which it succeeds or fails in finding parts of the loved one to seep into, to covet or revel in. When the loved object is in itself ill-suited, this development cannot run its full course.

This leads us back to Levin and the fields. In the sight of the

trees, Levin's resurgent feelings of life and hope and vigour find an ample object; latching on to that object his feelings develop further, they are nourished by the sight. The view of the fields does not start his recovery, but gives it support. The trees and fields in spring are rich, complex objects which absorb Levin's budding emotion.

Tolstoy is tactful. He seems to anticipate the danger of falling into a dry formula here. To say that someone's waking from a melancholy state is like the coming of spring after winter is merely to reiterate an age-old equation. Instead, he describes the landscape as seen through Levin's eyes and reveals his rejuvenation by describing his behaviour: giving orders, sharing a joke, getting off his horse to sow a line of oats with the peasant Vassily. This gives the feel of his vigour and new confidence. In reading the description of the land as seen by Levin, we are alerted to a further feature of the relationship between the land and the feeling of rejuvenation. There are many ways of looking at a stretch of countryside. One person will attend to certain aspects, another to others: these flights of attention will differ in what they bring together, isolate, how much or how little is attended to.

'To look out yonder now,' said Vassily, pointing to the field, 'it does your heart good.' But for it to do good, it is not enough that we just pass through the scene or drop ourselves before it like patients in a sanatorium wheeled on to the terrace and forced to see the Alps. We have to look at it, not merely see it. The description, by picking out details, presents a trace of Levin's attention, and this trace makes credible the fact that the sight has done Levin's heart good. What Tolstoy has captured is a normal (though perhaps under-used) resource of perception: the capacity for feelings to worm their way into object and be enhanced in the process.

*

It is reported that, interviewing for an Oxford Fellowship, one of the panel was surprised by the candidate's numerous artistic interests and inquired what he got out of art. 'I'm not sure what exactly I get out of art,' came the reply, 'but I know that I can put a great deal into it.' One of the things we can do with a picture or a building (or a field with snow lingering in the hollows) is put our emotions into it; in other words, invest something of ourselves. And what I have been trying to trace is the way in which interest is returned on that investment: given the right object to invest in, the emotion grows.

This yields an alternative to the raw application – imposition – of an external concern upon a work of art. An external concern can be invested in a work of art, the concern rubs up and into the work (as Levin's rejuvenation does in his fields); this searching out, seeping into, latching on to details is very different from the procrustean demand that the work correspond to extra-artistic concerns.

Passion

Sexuality is one interest, one worldly concern we might bring with us into the gallery, which generates particular problems. Because sex is sometimes so interesting – we can so easily invest our passions in sexy objects – sexual content in paintings stands as a test case of the role of interest in engaging with art. Neither the Bell option (forget it's a sexy scene you're looking at) nor the Jardine option (only think about the fact that it's a sex scene) is convincing. Tolstoy evokes a different kind of engagement, in which interest, as it were, finds a home in an object. But can we

25. Attributed to Pisano, *Daphnis and Chloe*. Sex as a first step on the ladder of love leading to the contemplation of God. Is his hesitation surprising?

give a more detailed description of this process in connection with specific works of art?

The classical story of Daphnis and his love for Chloe involves passions which are quite different from those we see in *The Rape of the Sabines*; it provided popular, mildly erotic motifs in painting and tapestry after 1559, when the story was first printed. Longus (writing probably in the third century AD) tells how, as children, Daphnis and Chloe were separately found and brought up by peasants. They are sent out to tend the flock together. One day the youth Daphnis comes up to Chloe, who is asleep, and he begins to feel sexual love for her. He is hesitant and she is coy. After various adventures they are reunited with their real, and happily noble, parents and are able to marry.

A picture in the Wallace Collection – which has recently been attributed to the fine but not very prominent sixteenth-century master Niccolo Pisano – shows the moment when Daphnis looks longingly but hesitantly at his companion (plate 25). His hand is drawn to her shoulder but we cannot tell whether he will touch her skin or draw back. The pronounced linear drawing marks out her skin as a definite boundary, an effect reinforced by the enamel-like finish to the painting of her milky flesh; touch, here, is the meeting of very distinct persons. The pursuit of details is recruited to give expression to the youth's hands: they are delicate and responsive; each joint is carefully noted and posed; his fingers are not just stumps of flesh and bone but the antennae of his soul.

Chloe's body is more supple and soft; her response is self-constrained, not inviting; her face is not voluptuous but rather delicate and refined; one hands hides under her elbow; at the right-hand edge of the panel we see her knees knocking together – slightly gauche to modern eyes and perhaps also to Pisano's

contemporaries. We sense the awkwardness of Daphnis in his gaunt, adolescent knees and elbows which protrude all the more sharply against their dark setting. His raised forearm is slender in proportion to his wide hand; his posture is slightly bowed – his shoulder edging forwards, his stomach is drawn in; his face is solemn and reverential. Although the loincloth nonchalantly slips from his thigh, this is a unvenial sexuality – shy and serious. The picture generates a mood in which we see sexuality as an intimation of higher loves. The material world prefigures obscurely the destiny of the soul and in so doing awakens a realization of that higher destiny: physical love as first step towards spiritual love.

The mood of taking sensuality seriously is furthered by the cool pastoral setting. The angular rocks have a certain austerity. It is not a terrain of luxury or graceful cultivation – but the trees are slender and sweet on the horizon and the delicate tones of morning brighten the lower portion of the sky. Behind Chloe, the folds of the land take up and repeat the lines of her back; the crag behind Daphnis seems to restrain his head, holding him back from a kiss.

In contemplating the work our interest in sexuality – our capacity to recognize and respond to movements and hesitancies of desire – plays an important part in coming to understand the painting, in coming to see how it works. In addition, in following our passion into the picture we may enhance our sense of what that passion is. We are, perhaps, returned to an aspect of sexuality which we have lost sight of or awakened to a possibility we did not suspect. There is thus a mutual play of picture and passion.

A painting by Boucher (plate 26) of the same scene – Daphnis approaching the sleeping Chloe – represents it in a very different

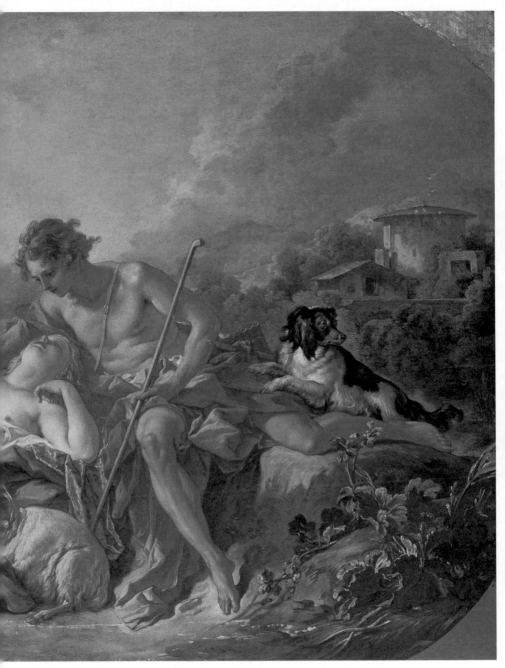

26. Boucher, *Daphnis and Chloe*. Erotic delight in a sexualized natural setting: sex as an end in itself.

manner from that of Pisano. The cloth which perhaps covered Chloe as she fell asleep has been cast aside (we may imagine her luxuriantly stretching and turning in her sleep) and evokes the disorder of bedclothes in the wake of love-making. The ribbons twined around the ankle and the wrist of the nymph and between her fingers create a point of entry for the imagined touch and their gentle pressure heightens the yielding, soft quality of the flesh. It is typical of this picture that a similar effect is achieved with the strap over the shoulder of Daphnis, typical, that is, in endowing both with a soft sensuality. The mood is playful: the lambs wear ribbons and suggest the nymph is lightheartedly playing at being a shepherdess as Marie Antoinette and her friends liked to do in the park at Versailles, where a little farm was arranged with gold milking pails and a couple of comfortable salons. It is sympathetic to the modern taste for role playing and artifice in sexual life.

Sensuality, in this picture, is not regarded as something primitive or unhygienic, to be spurned with increasing civilization, but rather as itself an achievement of civilization and culture. Sensuality itself is presented as an art-form, something which is to be refined, assisted with artifice, and prolonged (haste is the downfall of sexual pleasure) by bringing into play more and more subtle resources of enjoyment. The real task is to savour and spin out the moments of pleasure.

The atmosphere of the work is vaporous, slightly misty, which gives a palpable texture to the air; everything we see is softened and eased in accordance with this: there are no hard edges or sudden transitions in the picture. This encourages the eye to wander from point to point without any forceful compositional guide, and evokes a correspondingly physical ease. The continuous teasing and charming of our contemplative gaze is linked

to the visual enticements which are always at play in sexual encounters.

The textures of things (Boucher was celebrated in his day for the ability to render different surfaces) – the silky robes, the tender flesh, the cool glassy water, the fleecy clouds – these are all recruited to the business of sexual enjoyment, as if sexuality had spread out into the whole scene. The warm air drinks the glow of the lover's cheek and carries it like the perfume of a flower, joining it with the warmth of the depicted bodies rounded like fruit. The warmth and silence of the afternoon, the secretive branches and groves, propose a highly sexualized nature. Everything in the scene seems to invite a deepening of sensuous enjoyment; this pattern of diffusion and concentration is crucial to the idea of lingering over the pleasures of love. Sexual fun is here unattended by any further justification than its being pleasurable; it is shamelessly free from justifying reference. In Pisano's rendition of Daphnis and Chloe there was, in the wings, an intimation of sexuality having a distinct place in a greater general account of love, with sexuality always answerable to these greater considerations. In Boucher's work, it is as if these greater considerations fall away, or rather that sensuous pleasure stands as the great consideration.

These pictures indicate how very different emotions, attitudes and interests can be invested in works which have, specifically, similar depicted content. And this draws attention to the very different things that can happen to interests which get recruited into the process of looking. Far from judging the sexual content of the two pictures in the same way (either ignoring it or prejudging both as vehicles for sexual pleasure), the difference between the pictures, their contrast in mood and style, is brought out by the varied ways in which sexual interest engages with each.

Ideals

While enjoying the refreshing east coast breeze which seems to blow along Edinburgh's New Town streets on even the warmest summer days, the stroller's gaze might be drawn by a striking pediment adorned with statues (plate 27). It turns out to be the Royal College of Physicians, designed by the neo-classical architect Thomas Hamilton in the middle of the nineteenth century. Arresting though the building is, it is perhaps not one which attracts much love. All that self-conscious classicizing is apt to seem a bit remote in an age that prides itself on a more unbuttoned, relaxed approach to life.

Architecturally speaking, the Royal College turns an august front to the world, demanding respect, even reverence. It embodies, in other words, an idealization. Imagine the life which is supposed to go on in there: all dignity, erudition and calm authority (exactly the sort of professional face the doctors of Edinburgh would no doubt like to present). Idealization in a work of art has a bad name because it seems to try to coerce the spectator into adopting a certain attitude – here, of piety before a professional clan. It involves endowing something or someone (a profession, a person) with virtues more bright than they actually possess and removing any imperfections they may have.

In modern use, 'idealization' carries a pejorative charge. The simplification inherent in idealization strips away whatever is negative, whatever is complicated or disturbing, about an object. The worry is that if we are attracted to such simplified objects, if we praise them and take pleasure in them, we do an injustice to reality. For example, a painting which presents the countryside as a serene and elegant location for refined pleasure (as does the

27. Hamilton, The Royal College of Physicians, Edinburgh. An idealization
of professional dignity. Is this a dangerous building?

genre of the *fête galante*) might be criticized for excluding the economic reality on which this vision depends. Where are the sweaty servants who must tend the gardens and bring the wine and fruit; where are the peasants on whose labour the leisured class rely for their income? The fear is that in loving the picture we support the exclusion of certain crucial aspects of reality; that we retrospectively exploit the servants and peasants.

Another, more personal, issue is also at stake. We think that a person who has an idealized conception of some part of life is less able to cope with existence. Someone who imagines that little children can always be sweet, approaches reality with a brittle and unhelpful expectation. They are liable to turn in disgust from perfectly normal infantile behaviour and to make quite unreasonable demands upon the conduct of their own and other people's offspring.

Idealization, taken in this sense, reflects an immature, defensive posture of the mind which seeks, in short, a black-and-white universe. Splitting the world in this way gives protection from doubt: if, for example, I can identify with a cause I think totally right, I gain a reassuring self-conception – I too am good – and may find relief for anxieties about self-worth. Or a potential lover might be idealized (they would never do anything to hurt me, they will love me perfectly), which plays into the hands of a later denigration (they took advantage of my devotion, they never loved me).

Idealization eliminates (as defences tend to) a potential pain at a cost; any problematic evidence has to be avoided or denounced, thus disturbing real thought. The idealizing lover may find it impossible ever to have a real relationship, being disappointed before things ever seriously get going. Or they get going with someone whom they do not properly know because they have

been unable to acknowledge that person's weak points. The idealizing partisan cannot think clearly about the actual merits or demerits of the party (or leader) they follow. It is hardly surprising, then, if 'being realistic' – the antidote for idealization – appears to be a corner-stone of maturity. Hence the presence of an idealizing tendency in art frequently presents a barrier to the spectator.

These quite serious reservations help account for certain accepted artistic preferences in the contemporary world. It is normal to rate Van Gogh, with his gritty presentation of existence, or Georg Grosz with his relentless exposure of the cruelty which he takes to lie behind supposedly civilized institutions such as the Church and the law, more highly than the sweet maidens of Angelica Kauffmann or the calm grandeur of Reynolds. Van Gogh and Grosz give us reality; Kauffmann and Reynolds distance us from the world.

The fact that idealization has not always been regarded as a bad thing, and for long periods was thought to be the core aspiration of art, may tell us something useful. When painters present things as better than they are, they do not generally do so because their eyes are closed to the imperfections of the world. And equally, we may enjoy an ideal image without regarding it as a picture of how things are – albeit a false one. Ideal images don't, as a rule, seek to pretend that they are presentations of how the world is or ought to be; the expectation is that the spectator will recognize this. In fact the very notion of an ideal is contrastive. The pernicious force of idealization comes, precisely, when this contrastive sense is lost and the ideal is taken to be a description of how things are. We have been considering cases in which someone turns to an ideal because they can't bear to recognize how things

are. But it is perfectly possible to relish an ideal while seeing it for what it is; seeing it, that is, as a perfected and simplified version of some part of the world. Idealization of this kind is not an illusion. The impulse to create and enjoy an ideal image can derive from a thorough acquaintance with reality. It is because we know that things tend not to work out as well as we would like in life that the perfection of a work of art can strike us as particularly poignant. It ministers to a longing, not a delusion.

Think again of the idyllic country scene. This would present a false picture of society only if we regarded it as a thesis, or an assertion about how things are. But there is no need to do this. There are, after all, many ways of satisfying our curiosity about economic structures and about land management. That the picture ignores such matters does not license the inference that it seeks to prevent interest in, or care about, them. It would be an unnecessarily restrictive psychology that claimed we could only enjoy a fantasy of serene leisure at the expense of indifference to anything more painful or difficult. Such a psychology presents us with a fictitious either/or dilemma, ignoring the simple possibility of both/and. An ideal provides a way of keeping something beautiful in mind, it needn't be a way of keeping everything else out of mind. Holding on to a beautiful, though partial, vision may become all the more precious to us just because we are so aware of how rarely life satisfies our desires in particular respects. The image of leisure may be dear to one who works hard; the tranquil countryside to one who lives in an urban environment; an irritable person may love an image of stoic self-control.

Returning to the neo-classical façade of the Royal College, we should allow ourselves to enjoy it as an image of professional decorum and expertise without thinking that we are thereby colluding with a piece of professional propaganda. The ideal it pre-

sents is a noble and admirable one. We can respond to that while being perfectly well aware of the fallibility and imperfect motivations of the group of men who commissioned it. We can love the aspiration and welcome it as a guide to effort. A healthy enthusiasm for idealization is a crucial ingredient in our engagement with many works of art. These works are lost on us if we cannot respond with a certain thrill to their ambition to leap beyond the mixed condition of the world. And we should not be inhibited by the fear that in going with them we are thereby being unfair to the aspects of reality they exclude. The good spectator of such pictures is not the person who can see through the surface ideal to a corrupt undercurrent of exploitation but, rather, one who can share a longing for perfection; one who can see an ideal image not as a picture of reality but as a refuge for their own vulnerable, though precious, aspirations.

The power of caricature, to take the opposite of idealization, resides in its capacity for telling emphasis. It makes use of the fact that focusing on just a few exaggerated features can reveal something important about a person. Such an acceptable view as this should open our minds to the possibility that an ideal image, which also relies upon simplification and exaggeration, may equally have a revelatory function. And, in fact, this has been one of the most persistant claims which theorists have made for the arts. From antiquity onwards, with hardly a break until the nineteenth century, it was thought that an ideal image can be a vehicle for communicating insight and understanding.

What lies behind this thought? Why might someone think that an ideal image represents an insight? Suppose, to take a modern example, we were trying to imagine the perfect holiday. To do this, of course, we would have to think hard about what we want

from a holiday and to reflect upon just those features of actual holidays which struck us as particularly successful (or unsuccessful). The perfect vision which we create for ourselves would thus encapsulate our best insights into what makes for an enjoyable vacation. In such an example we see in a straightforward way how an ideal can be a compressed embodiment of understanding. And we might then regard any actual holiday as a more or less perfect realization of the ideal. The classical, or idealizing, practice of art applied this principle very widely. The image of the perfect hero, villa, vista, martyr, gentleman, mother, picnic or death (to give a sense of its range over many centuries) was founded upon an understanding of what is good or bad in any of these cases. The ideal is then just a harmonious presentation of the merits of any particular kind of thing with the defects we encounter in reality omitted. Of course, thinking about the perfect holiday may improve our understanding of what we enjoy about holidays; it makes just those features more noticeable by giving them prominence, by isolating them from the obscuring presence of all the other less appealing things which tend to accompany them in reality.

There is, then, nothing unreasonable in the thought that the creation of an ideal image can be a cognitive achievement and can have revelatory power. It was this thought which made the idealizing tendency in art central to a response to Plato's criticisms (most fiercely articulated in Book X of *The Republic*) of painting and poetry. Plato's point was that the artist does not have knowledge of what he presents. You don't need to understand (to follow one of Plato's example) how the bridle of a horse functions in order to be able to depict it accurately; you don't have to be a good judge of horses to paint a likeness of a horse. True, but if you are to depict an ideal horse, or capture an ideal

of good horsemanship, then you do have to proceed on the basis of understanding; that understanding is communicated in the work of art. And because the work of art presents, in such a case, a distillation of experience and understanding, the insights it communicates are more apparent in the work than they would otherwise be.

Taking a final glance at Hamilton's neo-classical building, we now see it as embodying a professional ideal. This ideal is not a piece of wishful thinking. It is, instead, a summary in architectural terms of what we most want from a professional body: reliability, dignity, learning, authority. It translates into stone an understanding of what professionalism is. It is eloquent and true.

Moral Sensibility

Antiquity – and indeed Western civilization as a whole until the eighteenth century – rarely doubted that there was a close connection between art and morality. One of the prime justifications of an interest in art was taken to be its ethically beneficial effects. In the twentieth century this connection has been challenged in two very different ways. On the one hand, many of the least attractive characters of twentieth-century history have been enthusiasts of fine paintings and architecture, etc. – most grotesquely represented by Nazi art-connoisseurs. On the other hand, some artists have explicitly declared that art has nothing to do with morality: 'No artist has ethical sympathies' (Wilde). But how seriously should we take these anxieties?

The evidence which stimulates the first unease can equally be interpreted along another line. Art, in its morally edifying role, is not – like a drug – automatically effective irrespective of the

capacity and willingness of the spectator to make use of what the work offers; but if someone is open to influence, art can have an impact.

The second worry thrives on an ambiguity in the word 'ethical' (also found in its sister term 'moral'). 'Ethical' or 'moral' can mean 'in line with conventional standards of the day' and, in this sense, Wilde makes an interesting point; it often is important to artists to stand in judgement upon conventional standards. 'Moral' and 'ethical' can also signal the open-ended investigation of what is humanly important; in this second sense, Wilde's own point is a moral one – it is part of the project of reflecting upon (not merely reflecting) the conventional wisdom of the day.

Although both these worries have passed into the folklore of philosophizing about art, neither is sufficiently serious to derail the classical assertion that art can sometimes be morally significant. However, there is, I think, a more pressing difficulty. If we consider ethics as the field of hard practical choices (whether to marry X, whether to devote medical resources to Y or Z) then, of course, it will not be to the paintings in the National Gallery that we turn for guidance. How could flat, coloured things possibly offer solutions to practical problems?

We are familiar with the ethics of the crossroads: the problems attendant upon having to make important practical decisions which will affect our own or others' welfare. We are familiar with the ethics of the boulevard, in which we require a set of virtues in order to get on well with our fellows. On the open road, however, we are by ourselves and there is no urgency about the particular turnings we take. (This might be called, inspired by J. S. Mill, the 'sphere of self-regarding actions'.)

A large part of existence is spent on the open road. The quality of life as a whole depends massively upon how we manage in this

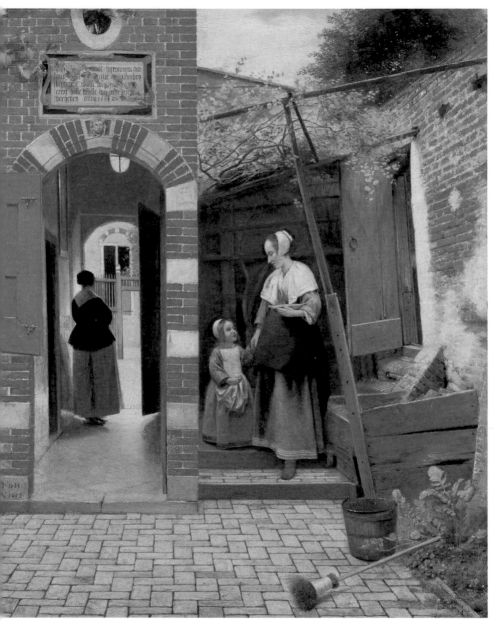

28. De Hooch, *The Courtyard of a House in Delft*. A visual education in the pleasures of domestic life.

respect. Depression, the sense of life leaking away 'in headaches and worry', intellectual lassitude, loneliness and an inner blankness or emptiness are familiar problems of this sphere. Flight from the open road may be just as grim: a busy preoccupation with trivia, a manic, inconsequential, grasping after excitement, a deathly cynicism. One could be a master of hard choices, generous, courageous and temperate as a May morning and find life tedious.

How can art help us on the open road? To focus on a particular picture, let us contemplate *The Courtyard of a House in Delft* by Pieter de Hooch (plate 28). We see (as if we were sitting close by) a narrow area of courtyard paved with yellow ochre bricks. The yard is scrupulously swept; a broom and pail are lying to one side. To the left we see into the passageway of a neat dwelling; a solid housewife (seen from behind) looks out into the public street beyond and we share her view of the window of a neighbour's house across the way. To the right a serving woman leads a child down a few steps from a worn and repaired garden door. They pass under a dilapidated but still functional trellis which supports an old climbing plant.

An overt moral is pointed by the tablet set into the house wall above the passageway which reads, 'This is Saint Jerome's Vale if you wish to retire to patience and meekness. For we must first descend if we wish to be raised.' In other words: patience and humility lead to moral nobility. The picture illustrates this moral by presenting a domestic scene which exemplifies modesty, quiet industry and patience.

Many of the visual qualities de Hooch presents in the picture are germane to the moral: tranquillity; a sense of place and of order; the positive enjoyment (visual and tactile) of things clean swept and scrubbed; their alliance with what is familiar and has

worn well, with what is homely and comfortable; a sense of internal spaciousness (of having time and space for what we need). Specifically, these provide an emotive and cognitive setting in which the worthwhileness of the moral attitude in question is made apparent. We are not presented with the simple assertion that domesticity is an ingredient of happiness and has its own nobility; the humane and the humanly appealing qualities of domesticity are made apparent in the picture.

To seize what the painting has to offer, it is crucial that our attention is directed across the whole surface of the work and it requires the contemplation of many of its aspects not, at first sight, directly concerned with morality at all. We need, for example, to dwell on the charming and relaxing quality of the patch of blue which indicates the sky, to savour the warmth of old stone, to respond to the texture of old wood, to be sensitive to the geometrical composition, to take in the virtual weight of the broom. It is in these sensitivities that the moral content of the picture comes alive. This is the point: it is precisely in such things in life that the value in question is realized (which explains why the moral power of the picture may well elude the spectator who engages only with its most obvious content). The painter has at his disposal – if only he has the skill, imagination and insight to deploy them – the resources to present these qualities to us in a purified and perspicuous way. But these are qualities of domesticity in the real world too (which is why what is revealed in the picture can be a communication of something morally important). The spectator who sees all this is in a position to grasp what is good about domesticity. They see something of how domesticity can be embedded in life, how it can focus and form a range of concerns and satisfactions, and how esteeming it involves a grasp of how these work together in reality.

It goes without saying that there is much which is not in the painting. It does not – perhaps no picture could – broach issues like whether domesticity is the only way of achieving these satisfactions, whether it has drawbacks, how it coheres or is in tension with other important things in life. But perhaps to have achieved even what it has is to have done much. Thus in engaging with the picture we have to draw upon our own moral sensibility: we make use of our capacity to regard certain qualities as good or as attractive, to see a mood as appealing and benign, to see a space as safe and relaxing. We are here investing our moral resources in the picture – and much of the interest of the work only comes alive when we invest in it.

Making use of our external interests and concerns we bring to art can thus be intimately linked to the processes of reverie and contemplation. Rather than provide a formulaic basis for acceptance or rejection (I hate/love X; if the picture has anything to do with X, I'll hate/love the picture too), interests and concerns can open avenues of inquiry and investigation. The invested passion helps unlock the work, and the work, in return, helps sustain and enrich the passion.

The word 'investment' highlights the fact that it is we, the spectators, who have to do this thing as we stand before the work. It is we who have to find attitudes and concerns of our own (bits, that is, of our own baggage) which we can bring to our engagement with the picture or building. And it suggests too that the interest the work has for us is directly related to the quality of the investment we make.

Private Uses of Art

What is Art for?

There are two different kinds of answer, at least, depending on the point of view you adopt. Your own, 'What can a work of art do for me?', or something less personal (perhaps, ultimately, as impersonal as the point of view of the universe, as Spinoza put it), 'What can a work of art do for society, the country, the universe?' That is, the question might be either 'What use can I make of a work of art?' or 'What uses are (or have been) made of works of art, regardless of whether I would want to employ them myself?'

'What is it to me?' takes on sceptical colouring in the face of much art-historical inquiry. In fifteenth-century Florence, for example, the commissioning and ownership of paintings was sometimes a matter of conspicuous consumption – a sort of sophisticated preening. To know about this is to know something paintings have been used for. But such preening is not now the sort of reason someone usually has for contemplating one of these pictures.

This structure is often repeated; many functions ascribed to works of art fall on the impersonal side of interest: propagandizing for the Council of Trent; keeping women in their place; glorifying the possession of land; gratifying a demand for souvenirs of

famous places; recording – and flattering – the appearance of family and friends. 'What is it to me?' helps to restore perspective. It can be demanded in a bolshy tone, as if any object is of significance only if its personal relevance is immediately explicit. There is also a more interesting way of asking it: an exploratory turn, in which interests and concerns are the sorts of things which might come out of hiding and develop.

But what of the personal uses which can be made of the contemplation of works of art by the individual beholder. Pleasure is the simplest of answers. It is, however, an incomplete answer. Pleasure is naturally attracting, it is internally linked to desire (and hence to the spring of action). 'Pleasure' is also a parsimonious term of description – it gives little away, there are so many different kinds of pleasure, and pleasures vary in the esteem we accord them. Things we especially value don't tend to be those that give the most intense pleasure, but ones that make the most sense to, and of, us. We need to know more about the kind of pleasure art can bring, and what it is about those pleasures which can matter to us.

Perceptual Pleasure

Although not all works of art are pleasing to look at, it remains a conspicuous fact that a great many paintings and buildings are a delight to behold. It is a general, but not universal, truth that works of art are a source of pleasure. This is the primary point we make in calling works of art beautiful; something we are often inclined to do. (Aquinas defines the beautiful as that which it is pleasing merely to perceive.) Pleasure is one of the major avenues of our private and personal use of art. However, it has to be

admitted that to say that we take pleasure in a painting or building is not to say very much. The fact is that pleasures vary hugely; it is not terribly informative to be told that an experience is pleasurable and hence to be classed with having your back rubbed and daydreaming, but not with going to the dentist or feeling a failure in life. Not surprisingly, then, a great deal of intellectual effort has been expended on the attempt to characterize more precisely a specific type of pleasure that works of art typically provide. The most famous and ambitious student of this topic was Immanuel Kant. His discussion of pleasure is contained in the *Critique of Judgment* (1790), affectionately known as the 'third Critique' in deference to the two monumental works which preceded it: the *Critique of Pure Reason* and the *Critique of Practical Reason*. (These titles sum up everything which is beguiling and annoying about philosophy: now you are going to get the answer to everything; unfortunately it will be incomprehensible.)

There are two ways in which we can classify pleasures: either according to the quality of their feel or, alternatively, with respect to how they come about. Kant follows the second route. He doesn't seek to tell us how it feels when we enjoy a work of art. Rather he attempts to explain what is going on in our minds when we take pleasure in beauty. And this is a pleasure we do often take in art, even though there are cases where the work does not lend itself to this.

Whether or not the pleasure of eating an apple, considered merely in terms of 'hedonic tone', feels different from the pleasure of getting your own way, we can certainly say that the mind is operating in quite different ways in the two cases. So, the question arises, What are our minds doing when we find something beautiful? Kant's suggestion is that two basic 'faculties' or capacities of the mind are simultaneously in operation, and that their

interaction has a special character. When we find something beautiful, he claims, our capacities for understanding and imagination are freely and harmoniously in play. This is a highly technical and compressed statement. To see what Kant is driving at we need to step back a little and give our attention to his general account of perception, presented in the *Critique of Pure Reason*.

Perception, Kant argues, is not a simple process. It involves the mind as well as the eye; specifically it involves both understanding and imagination. The eye receives the stimulus of light but this does not amount to seeing the visible world until that stimulus is ordered. Imagination and understanding jointly perform the task of giving order to stimulus. But how do they do this? What sort of order do they generate?

Consider first the task of imagination, as Kant conceives it. Imagination prepares the material of sensation for the reception of concepts. What this highly abstract formulation comes to is not very clear, but we might grasp it as follows. A child of eighteen months who doesn't yet have the concept 'green' (or even of colour) may still be tickled by the similarity of two green bricks. The child senses a pre-conceptual similarity; this is the work of what Kant calls 'imagination'. In adult life we might notice how one thing reminds us of another even when we cannot put a finger on what the common feature is. We could say that someone prone to this, or prone to feeling links between apparently diverse items, is particularly imaginative. If we see two colours as 'going together' or one curve 'answering' to another we are aware of a pre-conceptual order, of the kind which Kant thinks of as the work of the imagination. Baudelaire makes much of this type of affinity. I may hear a trumpet as silvery; a perfume may be redolent of the sky at dusk.

The anthropologist Claude Lévi–Strauss pointed to the 'affini-

ties' many cultures see between things for which they have (apparently) no concept. Thus a bronze shield may be thought of as having an affinity with the sun. The two are continually set together in the culture's stories and thoughts, but no explicit generalization between the cases is presented. We might want to say that this is because of the way in which polished bronze can reflect the sun's dazzling rays and replicate it on a small scale. In other words we can outline, using concepts, a real relationship; but there seems space for a pre-conceptual intimation of their imaginative kinship. It is precisely this pre-conceptual ordering which we find exhibited by that culture.

To move on now from imagination to understanding, the task of understanding is generalization. Kant (quite rightly) sees this as one of the most basic and impressive capacities of the mind and an essential characteristic of thought. It involves becoming self-consciously aware of the common features which hold across multiple instances. It thus enables abstraction from particular cases; general features can then be grasped in their own right. And, of course, it is upon this foundation that the entire edifice of thinking is erected. The ordering which understanding provides is, then, one that depends upon the application of concepts. We see that shiny patch as a nose, those pointy bits as teeth; they are simultaneously seen as parts of a head, and the head as part of a dog. A whole conceptual structure, which relates part to whole, is implicated in this very simple act of perception. Without that structure our seeing would not have the ordered character it does.

Kant's contention is that both these ways of ordering perception are involved when we find something (a flower or a work of art) beautiful. More specifically, they are involved in what he calls 'harmonious free play'. What does this impressive, but

obscure, phrase come to? Let us start by considering the 'free play' aspect. The key point signalled by the word 'play' is negative: imagination and understanding do not fully carry through their ordinary task in the case of aesthetic response. Suppose we are looking at an oak tree in full leaf. We might be struck by the juxtaposition of the leaves and the bark; the leaves seem so different and yet of a piece with the bark. We might be struck by the way in which each cluster of leaves is itself part of a larger grouping which in turn is part of the bole. We can trace the twisting of the branches, feeling a certain overall pattern yet continually losing and re-finding the path of any individual branch. And much the same could be said of looking at a painting of a tree.

In such a case, we make a perceptual synthesis that approximates to, but does not actually arrive at, a generalization. It is as if the process of ordering we considered as belonging to imagination becomes more and more elaborate. The affinities sensed between elements of the visual scene are unusually strong. It is as if the understanding is moving towards a generalization but not quite getting there. The order we find in the tree, when we look at it this way, almost crystallizes into an explicit conceptual relationship, but not quite. Understanding, as a vehicle for order, is in play, but what we experience is not an order derived from understanding. Kant's great point here is that to have this kind of experience you need to have the capacity for understanding, even though in such a case the capacity is being used in a special way. The experience of beauty derives from our basic cognitive capacities; only creatures with such capacities can find things beautiful.

Support for Kant's account can be found in the failure of 'Academism'. Academism is the idea, very popular in the eighteenth century, that a rule can be provided for making or judging beautiful objects. To be beautiful is simply to conform to that

rule. But this ambition has been severely discredited by the observation that, no matter what rule is presented, it is possible to find objects which conform to it but which do not delight. The fact is that we cannot provide a rule for generating or judging beautiful objects. We can say in a fairly abstract way what is required if something is to be a dog or a violin or a cloud. But there is no equivalent of this with respect to beauty. We cannot say that to be beautiful an object must have a particular structure, or must be made of certain materials, or must be suitable to fulfil some easily describable function. The only way of deciding whether something is beautiful is to perceive it yourself. And in perceiving it we are not trying to discover whether or not the object conforms to some rule. Kant, thus, offers an explanation of a fact which any adequate account of what the mind is doing when we find something beautiful must respect. Namely that seeing beauty is not the same as recognizing that the object conforms to a typical pattern.

All this very abstract discussion has a crucial practical consequence. We should not think that we become more sensitive to the pleasure art and beauty afford by becoming more informed or better conceptually equipped. On the contrary, what we must do is give ourselves over to the free play of our native capacities for finding affinities and non-conceptual order in the objects we contemplate. Kant's position is radically egalitarian with respect to beauty. The enjoyment of beauty is equally open to everyone. For what is required to enjoy beauty is no more than the capacities we already possess and which we make use of (although in a different way) in our most ordinary perceptions. And this is surely right. However difficult it is to describe what goes on when we find something beautiful, it isn't difficult to have the experience itself. There is nothing simpler than finding a sunset beautiful. This

holds good of some, if not all, works of art. And it is always salutary to be reminded that at least some of the delights art offers are not particularly demanding. (Although it is ironic that this reminder should come from Kant in one of the most demanding books ever written about pleasure.)

But what of the 'harmony' in Kant's vision of the free harmonious play of imagination and understanding? When imagination and understanding work together, as they do in an experience such as that of looking at the tree, we have a blissful sense of ease; our minds are working without strain; we are in our perfect perceptual state. Rather than imagination being subordinate to understanding, or (alternatively) imagination being bereft of understanding, in these special cases the two have equal weight and pull together. This is a terribly elusive point, but perhaps there is something in it. Take metaphor as an instructive instance. If I say, with Rilke, that the sun is feverish, clearly this is not to be taken literally. This is not an ordering of understanding, in which the sun is taken to be an item which belongs to the class of things that have fevers (like people coming down with flu). The metaphor rests upon the kind of affinity we considered as belonging to imagination. Yet, in reading it as a powerful metaphor we feel that it speaks to the understanding. It is not a chancy or arbitrary linkage; it is rich in implication and suggestion. It does not yield explicit understanding but speaks to understanding. If imagination were subordinated to understanding we would just give up on the metaphor and regard it as an absurd factual error. (Philistinism may be defined as the permanent subjugation of imagination by understanding.) Yet if imagination takes the upper hand and dictates to understanding we end up with another problem. We regard the statement no longer as a metaphor but as a literal truth. (Mysticism and dreams make

understanding surbordinate to imagination.) Appreciation of metaphor requires the cooperative play of the two capacities.

There is one further positive claim Kant makes about the way the mind works when we find something beautiful. When we find something beautiful we do not do so simply on the strength that it serves a particular purpose or function. Kant believes, however, that our ability to recognize, see and comprehend purpose is profoundly implicated in the enjoyment of beauty. Thus he can let us feel sympathetic – and not merely dismissive – towards one traditional conception of beauty which sought to identify it with the perfect fulfilment of a function, a tradition which still finds adherents in those who take the slogan 'form follows function' as saying that beauty is an outcome of functionality.

To follow Kant's complex reasonings on this matter we first have to take on board a distinction he makes between particular purposes and the category of purpose in general. The capacity to recognize a particular purpose presupposes a more general and abstract capacity: that of working with purposiveness. And he holds that we can work with the general notion even when we do not acknowledge any particular explicit purpose. If this seems obscure, consider a case from painting. Suppose we are looking at a portrait. We may well want to say that the posing of the hand in relation to the head seems highly deliberate; it is as if there is some purpose being served by their juxtaposition, though we would be at a loss if pressed to say explicitly what that purpose is. Or take an example from literature. *Anna Karenina* involves two fatal railway accidents, one very near the beginning of the novel, the other at its end. We grasp this as a highly purposeful repetition, but do so without having any clear account of what that purpose is. In other words, Kant seems to be right: not

only does our sense of purpose-in-general play a role in the enjoyment of art but it does so (in conspicuous cases) without being attached to specific purpose.

We might admit all this without being very impressed. Why does this matter? Kant's (surprising) point is that this capacity, for recognizing purpose without reference to a specific purpose, is one of the most central abilities of the mind; indeed it is the one on which our understanding of the world ultimately rests. For it is this attitude ('it seems to make sense although I cannot pin the sense down') which fuels the optimistic, but more or less universal, belief that the world is ultimately comprehensible. It is this attitude which underwrites the pursuit of explanation in advance of its possession.

Kant's view, then, is that beauty ministers to some of the most profound needs of the mind: for imaginative and conceptual ordering and for the intimation of general, but not explicit, purposefulness. Kant's achievement is not to have put to rest the question of the mind's role in the experience of beauty and of art. It is to have set us upon the path of attempting to do justice to the richness and complexity of what goes on when we take pleasure in a beautiful object or work of art.

An obvious criticism that one can make of Kant is that he has cast his net over too restricted a range of human capacities. It is certainly interesting to reflect on the peculiar interaction of imagination, understanding and a sense of purpose; but why should we limit discussion to just those resources? One might be impressed by the account of how these capacities enter into the pleasures art affords without being convinced that this is a complete and definitive account of how the mind works when engaging with beauty. This criticism seems to have been taken seriously by one of Kant's most creative disciples, the playwright and

enthusiastic theorist, Friedrich Schiller. And in the next section we shall turn to a consideration of Schiller's own account of the satisfaction which art can yield.

The Whole Person

Friedrich Schiller (1759–1805) acquired early fame as a dramatist, but a significant portion of his later life was devoted to philosophy, particularly to the prolonged digestion of his reading of Kant. His major work in the philosophy of art is the highly wrought series of letters, *On the Aesthetic Education of Mankind*, published in serial form in his own literary–political journal, *Die Hören*, during 1794 and 1795. Schiller presents an extraordinarily ambitious vision of the good art and beauty can do the individual spectator.

He seeks first to identify some root, essential difficulty of the human condition and then to persuade us that beauty and art offer a very special sort of help in coping with, and perhaps ameliorating, this difficulty. Indeed, he thinks that when understood properly beauty and art present themselves precisely as responses to a core human need. He thinks, in other words, that he can identify an art- and beauty-sized hole in human nature. His basic questions are: What kind of thing are we? What is the most elemental problem presented by the bare facts of the human condition?

A crucial feature of experience is the contrast between an enduring sense of selfhood and changing circumstance. It is the single, same 'me' who thirty years ago lay down for an afternoon nap in the front room of my grandparents' flat, listening to the sound of the traffic outside, and who this afternoon laid my own son in his cot for his lunchtime sleep. Yesterday I took a bleak

view of my life; today I have a rosy outlook; but it is the same 'me' which has these different attitudes. 'We pass from rest to activity, from passion to indifference, from agreement to contradiction, but we remain,' as Schiller sums it up in Letter 11. Although the division between person (*that which endures*) and condition (*that which changes*) is couched in technical language, Schiller advances it as an instantly recognizable and omnipresent psychological fact. This is a basic feature of how being human presents itself to us.

He is quick to line up other big terms on either side. The capacity for reasoning is annexed to the enduring self. The continuing self is not just a minimal, empty point of view. On the contrary, it has a dynamic aspect of demands and drives. The enduring self, according to Schiller, seeks to order experience in a rationally unified way, to provide itself with explanations and 'laws' which govern experience (if you do X, Y will probably happen, etc.). This constitutes a self that is continuous across radically divergent experiences.

Rationality, then, involves seeing connections, similarities and formulating rules. The function of reason that interests Schiller is the search for meaning. The sense of meaning in one's life depends upon seeing the relevance of one experience to another, seeing how they illuminate each other, how one makes another possible. Putting my own child to sleep becomes a much richer, and more meaningful, experience if held in conjunction with recollections of being a child. But it is also meaningful because I believe that a well-rested child is likely to be happier than a tired one. As Schiller puts it, rationality reaches out across time and tries to bring many distinct experiences together into a coherent unity. It is the part of oneself that tries to construct a coherent life-story.

Schiller calls this the 'form drive'. The basis for this appellation is simple enough: reason is concerned with the relations between elements, and 'form' too can be glossed as the structure that holds among elements. But introducing the notion of form, with its unmistakable artistic resonance, reminds us that this discussion of human nature is a prelude to the discussion of art and beauty.

While person is aligned with rationality, condition (the second half of two-fold human nature) is connected with sensuality. This connection is founded on the recognition that we often want to fill each moment with as much sensation as possible and to lose ourselves in stimulation. In a famous passage, Pascal declared that we are unhappy only because we are unable to sit quietly alone in a room. We are prey, he notes, to an irrepressible urge to distract ourselves, to fill up time and, to my ear, it is this same urge which Schiller is naming as the 'sense drive'. At this point one can hear, through the technical prose, the echo of Schiller's own experience: the smoker's longing to concentrate on the inhale and exhale to the exclusion of all else, the gambler's obsessive concentration on the spasms of anticipation, fear and hope.

However, we would misunderstand Schiller's conception of the sense drive if we construed it primarily as a demand for stimulation and excitement. More generously, it is allied with interest in contact with the world. This interest is given characteristic utterance in Goethe's account of his Italian journey. (It was immediately on return from his extended stay in Italy that Goethe established a friendship with Schiller which would last until the latter's death.) 'My one desire is that nothing shall remain a mere word to me; anything that is reportedly beautiful, great and venerable, I want to see and judge for myself.' And, 'I shall never rest until I know that all my ideas are derived, not

from hearsay or tradition, but from my real living contact with the things themselves.' We are, here, far from a demand for sensuous indulgence, but the sensory character of experience is still prominent. Immediate experience is stressed at the expense of ideas. The point of calling this a drive is to signal its imperious, demanding character. It is a continuous spring in our nature urging us to particular actions.

We are seeking a root for the appeal of art and beauty in the basic features of human nature. As we have just seen, the first step in Schiller's account of the matter is to draw our attention to two drives. On the one hand, drive towards coherent, meaningful experience which allows us to spread ourselves over time; on the other hand, an impulse to intense feeling which is indifferent to narrative. To see where art and beauty come in we have to follow Schiller's analysis of the human condition a further step.

The moments of intense feeling, to which the sense drive urges us, frequently come into miserable conflict with the demand for meaning and unity across time. The hangover, the remorse for money wasted, the sense of guilt, all testify to these uncomfortably dual drives. The observation that sense and reason can conflict is hardly novel. Plato was, of course, deeply interested in this issue, and it was taken up wholesale by Christian thinkers under the guise of the war of the flesh and the spirit. But Schiller adds a new and attractive turn to the old discussions; rather, two turns. First of all, he thinks of the claim of reason in an appealing way, as the search for meaning and coherence in life. This is a more benign model than the demand that we love reason for its own sake, as Kant had it, or because it is the viceroy of God. The second contribution is the thought that subordination of one to the other (reason to sense – the romantic ideal, or sense to reason – the classical and Kantian ideal) is unsatisfactory. If we follow

either of these subordinations we lose some important aspect of ourselves and are diminished as people.

Conflict between these drives comes about, Schiller suggests, in a striking political metaphor, because they colonize each other's territory. If we look to intensity to give meaning to our lives, we are trying to get sense to play the role of reason. When, on the other hand, we try to get the pursuit of a law-like, rational exist-ence to constitute the whole of our life, reason usurps the role of sense and leaves us dry, unsociable and unsympathetic. In a long footnote to Letter 13 he writes: 'The pernicious effect, upon both thought and action, of an undue surrender to our sensual nature will be evident to all. Not quite so evident, although just as com-mon, is the nefarious influence exerted upon our knowledge and upon our conduct by a preponderance of rationality.' And he supplies two important instances of this pernicious effect.

The first concerns the pursuit of science and the general study of nature. 'Instead of letting nature come in upon us, we thrust ourselves out upon her with all the impatient anticipations of our own reason.' We hear echoes surely of conversations with Goethe, whose pride was the way he had trained himself to observe, to let himself be led by what he saw without allowing expectations to govern his perceptions. His 'clear eye' would sim-ply take in what was there to be seen. It would be strange, today, to counsel scientists to be observant. But if the point has been assimilated, even made a cult of in the natural sciences, it remains vital in private life. What we as individuals can recognize and understand in other people and in our environment is prey to how observant we are, how receptive we are to the delivery of experience; a delivery which is all too easily miscarried by the intervention of rationalization. That a highly rational person can be unreceptive or imperceptive is hardly surprising news. But it is

news always worth repeating, and Schiller is a striking advocate of this point because he announces it not from a position of hostility to reason but with a sober appreciation of reason; only it is an appreciation that does not extend to idolatry.

The second way in which reason can encroach perniciously on feeling is in the domain of morality. 'How can we, however laudable our precepts, how can we be just, kindly and human towards others, if we lack the power of receiving into ourselves, faithfully and truly, natures unlike ours, of feeling our way into the situation of others, of making other people's feelings our own? But in the education we receive, no less than in that we give ourselves, this power gets repressed in exactly the measure that we seek to break the force of passions, and strengthen character by force of precepts.'

Thus it is no help, in our predicament, to subordinate one drive to the other. Rather, what is needed is reciprocal inter-action to keep each drive in place. We need both. We need depth and diversity of experience; we need passion but we also need order, coherence and continuity. The question is: What could enable us to keep these expansive drives in place?

The solution Schiller proposes to this question is as remarkable as it is original. Coming at the end of a long line of thinkers who have proposed either the superiority of reason, or the sanctity of sense, Schiller suggests that neither holds the key to success in life. Rather, there is some third thing, some further and hitherto under-appreciated aspect of our nature, which has influence over both and encourages their harmonious cooperation. And this third thing is play.

But what is play? Although play often involves very specific aims – to build a tower of bricks, to score more goals than the other side – it does so in a curious way. A game of football is not

wasted if you are on the losing side; you can love playing the piano even if you never progress beyond grade four. A child knocks over its bricks as soon as they are up, or abruptly, but guiltlessly, switches from building a station to making a castle. Purpose is present, but light. Play is internally related to enjoyment; it comes easily, we don't have to gear ourselves up for it; it is inviting. It frequently involves rules yet, however emphatic the rules, they have force only within a small area and are designed specifically to heighten the pleasure of participation. Football players are denied the right to use their hands not out of meanness, or footism, but because this gives focus to a certain range of skills. We feel in harmony with such rules, not oppressed by them.

Schiller presents play as keeping each of the two basic drives in its rightful place. When we play we are not searching for meaning in our lives as whole, although the demand for meaning and coherence is rewarded; we are not overwhelmed by sensuality, although feeling is rewarded. When we play, both the sense drive and the form (reason) drive are operative; yet play would be compromised – or annulled – if either of these drives got the upper hand. If the sense drive took over, the game would disintegrate, its thread lost; if the form drive took over, then the fun of the game would disappear. Play, then, is perfectly suited to instantiate the balancing process which Schiller is in search of.

By identifying a specific 'play drive' Schiller is claiming that we have an a-cultural, innate urge to play; and this claim is not fanciful, for we associate play with infants and children, and find versions of games and attitudes of playfulness in a very wide range of cultures.

At this point it might be thought that Schiller has taken us down a blind alley. We accompanied him on his exploration of

human nature because we thought he was going to lead us out at a vantage point from which we could get a clear vision of the role of art in an individual life. Instead he has presented us with an account of play. In fact, Schiller is nearer his goal than we might think. For, surprisingly at first sight, he wants to argue that the perfect arena for play, the primary instance of play, comes not in the nursery or on the sports field but in the art gallery. In a moment we shall see why he thinks this.

The object of the play drive, what it seeks out, is 'living form'. This obscure and abstract formula simply derives from Schiller's conception of the play drive as emerging from the two more basic demands he has demarcated. When we search for meaning we are enacting a demand for order, or 'form'; when we are taken up with feeling we are responding to a demand for life. He puts the two together and concludes that the desire to play is a desire for something that unites life and form, namely living form.

The object of the sense drive, expressed in a general concept, we call *life*, in the widest sense of this term: a concept designating all material being and all that is immediately present to the senses. The object of the form drive, expressed in a general concept, we call form, both in the figurative and in the literal sense of this word: a concept that includes all the formal qualities of things and all the relations of these to our thinking faculties. The object of the play drive represented in a general schema, may therefore be called *living form*: a concept serving to designate all the aesthetic qualities of phenomena, and in a word, what in the widest sense of the term we call *beauty*. Letter 15, paragraph 2

Although footballs and building bricks might furnish the most obvious things we play with, the drive that is operative when we play is most fully at home with objects of beauty and works of

art. This is an amazing realignment of kinship. Where the Middle Ages had seen art as close to religion, or the Renaissance had regarded scholarship as crucial to the enjoyment of art, Schiller gives us something very different. Our capacity to enjoy art and beauty, he tells us, is vitally connected with the pleasures of childhood leisure hours and with the enjoyment of sport. Think of the intricate, harmonious order of a well-laid-out train set; think of the child saying, 'I'm a pirate; imagine the ship is sinking; imagine, imagine.' Think of the excellent tennis player who is perfectly poised, whose strength is harnessed by timing and technique. Appreciation of these things is continuous with appreciation of qualities we can find in works of art. It is a lesson we are still learning.

Because of the way we are psychologically constituted we seek, and cannot help seeking, living form. This is a crucial juncture in Schiller's whole aesthetic theory. For the notion of living form looks two ways. On one side it corresponds to a basic human concern; on the other side it is the basis of his account of art and beauty for, he wants to insist, beauty is nothing other than living form itself. If he can pull this off he has found a way to ground our interest in and attachment to art and beauty in a fundamental human need.

Schiller finds it easy to move between a discussion of beauty and a discussion of art, more easy than we do today. Schiller certainly did not think that art and beauty were coextensive terms; he found beauty outside of art. Yet when he was writing it was not difficult to believe that the creation of beauty is a central goal of art. Although this could no longer be insisted upon, it remains obvious that a great many works of art are beautiful and what Schiller has to say is relevant to our engagement with those works. His theorizing may not have the universal relevance he

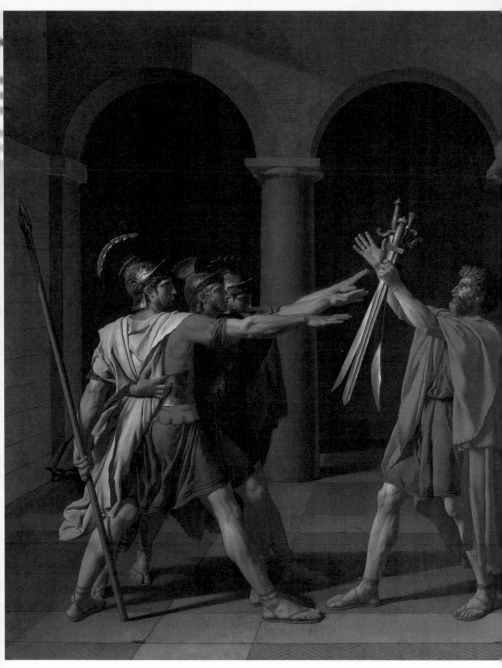

29. David, *The Oath of the Horatii*. 'Tensing beauty.' The picture appeals to our rational nature but rewards our sensuous aspect too.

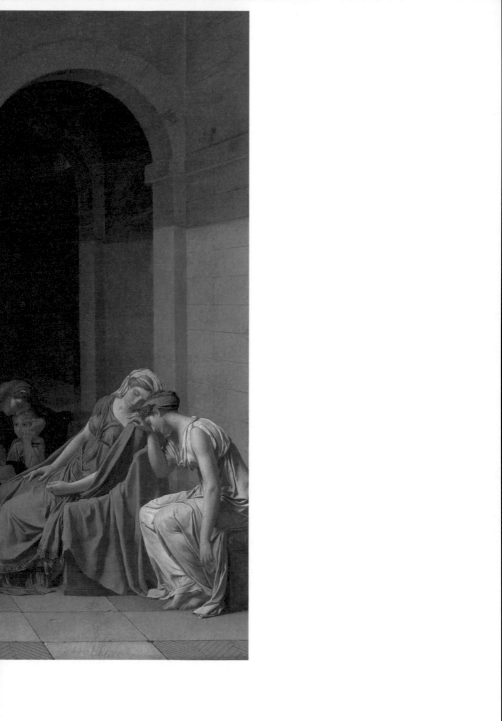

aspired to, but it can still be pertinent to our engagement with many works of art. On reflection, this is probably the most we can hope for from any deep theory about the human significance of art. For so many different things have been done in the name of art that it is highly improbable that anything deep can be said which is relevant to all works of art. Although the ambition of philosophers has frequently been to make universal statements, it is actually a higher achievement to say something substantial about even a limited number of artworks.

In defining beauty and beauty in art as the object of the play drive, Schiller believes he has done more than provide just one more intriguing formulation for a perennially elusive term. He dignifies his definition by calling it the 'pure rational concept of beauty'. What is he getting at in this phrase? He uses the adjective 'pure' in a sense borrowed from Kant. A 'pure concept' is one that reveals the structure of experience, as opposed to one, like 'table', derived from empirical observation. In other words, Schiller hasn't looked at lots of beautiful things and tried to decide what they have in common and finally concluded that it is living form which they all exhibit. On the contrary, what he has done is start by considering the essentials of human nature and found there a fundamental need for objects which display living form. It is this need which anchors the term 'beauty'.

By saying that the concept is rational, Schiller is also making use of Kantian vocabulary, with a precise technical meaning which is easily lost on his modern readers (and no doubt on many of his contemporaries). Kant distinguished strongly between two kinds of concepts, those of understanding and those of reason. Concepts of understanding can be used to describe how the world is. Concepts of reason, on the other hand, don't describe the world but elaborate our perspective on it. 'God',

according to Kant, is a concept of reason, in that God is not a feature of the world, not a possible object of scientific inquiry. Equally 'freedom', which is crucial, Kant thinks, to our view of ourselves, does not describe a part of the world. Freedom is not a part of the world, but a part of how we (necessarily) conceive of ourselves. Now Schiller seeks to expand the catalogue of concepts of reason to include that of beauty.

At first sight this must seem strange, because we ordinarily think of beauty as a property of objects and therefore of 'beauty' as a term which describes some things in the world. Schiller's definition of beauty, however, is not to be grasped as an attempt to characterize a feature of objects. Instead, what it does is present an ideal by which it is always possible for us to be guided in reflection upon ourselves and our lives; this ideal concerns the balance of the sense and the form drives, when these are taken up together in play. One virtue of this is that Schiller has no difficulty with the extension of the term beauty to behaviour, attitudes and ways of life. It is in no way foreign to his enterprise to say that someone has a beautiful nature or personality.

The mutual cooperation of the two aspects of our nature, under the guidance of the play drive, then constitutes a standing ideal of human nature at its best. Although the claim is advanced in the abstract, Schiller is evidently concerned with something he felt his readers might recognize in their own experience. At certain privileged moments we act and feel and think wholly in concert with ourselves. In Letter 14 he suggests that such experiences offer 'a complete intuition of our human nature, and the object which affords this vision would become for him a symbol of his accomplished destiny'.

Having said this, Schiller introduces a reservation which, as its force is felt, adds an attractive subtlety to his thesis. The objects

30. Boucher, *Spring*. 'Melting beauty.' The garden of earthly delights;
it also has a fine compositional logic which excites and satisfies the
form drive.

which we call beautiful, the objects which we encounter in reality, never quite present, or evoke, a perfect harmonization of reason and sense. They always incline a little to one side or another of our nature. Balance is a matter of degree. Such objects may be, in this special way, a lot more balanced than many things. But still, they do present an image only of the imperfect, comparative harmonization of our two sides. This apparent retreat is actually an advance.

On the one hand, a work of art may incline more to our rational aspect, in which case it is an example of what Schiller calls 'tensing beauty'. By this he means an object which has the effect of strengthening the sway of our rational aspect, giving greater weight to the force of rule and reason within us, or at least representing these in an appealing, and hence inspiring, light. Take, for example, David's neo-classical masterpiece *The Oath of the Horatii* (plate 29). This restrained and dignified work shows the three brothers, the Horatii, taking a vow before their father to defend Rome, alone if need be, against the invading forces at a moment of emergency, when the authorities have failed to protect the city. David's picture makes an appeal to our rational nature but, of course, not only to that. It provides us with an image of devotion to a concept of freedom, a concept which, Schiller thinks, appeals to our rational nature. On the other hand, a work may have more inclination to the sensuous side of our nature. Take, for example, Boucher's *Spring* (plate 30), which shows two charming girls reclining in a beautiful valley eating grapes. It is painted in the rococo manner: full of soft curves, delicate mists and gauzes. It is like a vision of complete sensuous delight. Schiller calls this, in an exact turn of phrase which over-use has reduced to a commonplace, 'melting beauty'.

Each kind of beauty has something slightly different to offer

us. The person more given to severity of thought may be seduced to a balancing sensuality by way of the contemplation of Boucher's painting. Schiller is an acute student of how we may be insufficiently sensuous. The work of art is available to this sort of person, not only because art is highly respectable and has acquired spiritual authority over time, but also because even a highly sensuous work like Boucher's appeals to our intellectual aspect as well. It is logically composed; it makes reference to contemporary pastoral plays; it can be understood in the light of aristocratic habits and preoccupations of the day. All of these provide acceptable points of entry for rationally minded people. This is not to say that the picture can be fully appreciated in these ways, just that these aspects provide a way in for someone who can only enjoy something which is intellectually serious. But having been granted this approach, Schiller believes, the painting then provides such a viewer with an opportunity to develop their neglected powers of sensuous enjoyment. And, crucially, it allows them to do so in a setting that seems safe, while someone given to sensuality may be delighted by the beautiful composition and elegant lines of David's painting, only then to feel the power and vitality of the heroic ideas which it resents. The demands of reason are made apparent to such a spectator but only in a setting which recognizes and caters to their temperament.

Schiller's humanity is never more apparent than in his recognition of our need to have our anxieties assuaged before we can extend our sympathies. He accepts that the sensualist will only see the charm of reason if it is made available in sensuous guise; that the rationalist will only acknowledge the claim of sensuality when that claim is made rationally. And whether we are sensualists or rationalists, it is in art that we find the perfect vehicle for a cautious, but real, enhancement of existence.

Kant attempted to show how the enjoyment of art fits into the cognitive economy; that is, into the general activities of the mind. Schiller works with a larger canvas, considering how the enjoyment of art fits into life as a whole. In each case, I think, we are entitled to object that the accounts are incomplete. Kant considers some aspects of mental life, Schiller some features of life in general. Both contribute to our understanding of the private and personal use of art without bringing that understanding to completion.

Being at Home in the World

Hegel (1770–1831) was the most important philosopher in the generation that followed Schiller. Like Kant, his thinking about art is profoundly connected with his wide-ranging claims about the human condition in general. Like Schiller, he sees art playing a crucial role in the experience of individuals (and of societies) because of its capacity to integrate powerfully divergent aspects of our own nature; in this respect, Hegel is clearly under the influence of Schiller. However, he conceives these forces in a way that diverges from, but does not contradict, his predecessor.

Hegel holds that our capacity to think about ourselves, which he calls 'reflection', has brought conflict into existence. Unlike the rest of the animals, we do not merely have beliefs and desires; we also have beliefs and desires about our beliefs and desires. We may regret our actions or feel justified; we may doubt a proposition or have faith in it; we may wonder what justifies a conviction. We posit explanations and develop abstract, general terms that facilitate classification and understanding. It is typical of Hegel's account of history that a real advance (the development of

thought) is experienced as problematic and as a loss. Why? Consider the views of Plato which, Hegel thinks, constitute the culmination of this tendency. The subtlety and rigour of Plato's thought was a huge improvement upon anything which came before. He liberated thought from superstition, made belief answerable to justification. He showed the systematic relations between many different areas of thought. For example, he showed that what we think about poetry might depend upon what we think the value of emotion is, while that, in turn, will depend upon our account of the nature of the soul. And any adequate account of the just or good society will be founded upon our understanding of all of these issues. This is a major advance. Yet, according to Plato, real existence is purely intellectual, the world of experience is shadowy and degraded; the senses lead us into intellectual and moral error. We are split in two. The world in which our bodies exist is a prison. The intensity and rigour Plato wonderfully introduced into thinking turned thought into an enemy of life. Real progress has brought major problems with it. And although Hegel is explicitly concerned with a particular stage in the history of thought, this opposition must have a painful familiarity for many modern individuals. Hegel has identified a universal phase of intellectual adolescence.

The positive work of culture, work that fills the entire subsequent course of history, is the pursuit of an adequate reintegration of thought into life. Adequate, that is, as recognizing the merits of, rather than suppressing, reflection. Culture seeks to reconcile what has been divided, but at a higher level. Hegel posits many such reconciliations, although none is complete. For each reconciliation brings with it a new source of suffering; albeit of a more sophisticated kind. And art, in Hegel's view, is one of the principal modes of reconciliation. In so far as art is a

way of bringing ideas back into intimate connection with feeling, imagination, desire and perception it is a means of allowing us, as rational beings, to find ourselves at home in the world of appearances, the world in which we must live.

It is this thought which lies behind Hegel's characterization of the business of art as the sensuous presentation, the embodiment, of ideas; specifically of those ideas which matter most to us. It is, he claims, precisely because art does this that it occupies a significant place in the history of culture. This is why art is important; ironically, it is also the root of the limit of art's importance. Art allows thought to be at home in the world of perception, feeling and desire. But only certain kinds of thought can be provided with such a domicile.

We get a clearer sense of this by reflecting on one of the pinnacles of art: Greek sculpture. A statue of Apollo, when realized with maximum skill and delicacy, does not merely stand in a symbolic relation to the god; it is a completely adequate embodiment of all the Greeks were concerned about. There is, here, no gap between idea and experience, and it is art which has brought this about (a less skilled, less delicate sculptor would not have been able to create an adequate image). But the adequacy derives, on the other hand, from the limited conception the Greeks had of Apollo in the first place. Their vision of their god was not abstract; it was focused on external qualities. A definitive feature of Apollo was his physical beauty and this lends itself perfectly to being realized in art. When we come to the Christian era, however, things have changed. The conception of God has deepened and become more 'inward'. The truth of Christianity (what it is most concerned with) is a quality of inward life: faith, prayer and love. And these, not being features of the perceptual, external world, do not open themselves so easily to being presented in art.

Of course you can make a statue or a painting of a man praying: kneeling, eyes raised, hands joined etc. But this is not what is important in prayer. What matters is what is going on inside the person who is praying. A cathedral or a great piece of religious music may do much to convey the mood of prayer, the attitude of adoration and so forth, and so may correctly be said to give a sensuous presentation of religious ideas. But this is a far from perfect embodiment. However beautiful the building or the sounds it cannot capture the core point: that it is the quality of the individual's private and inner relation to God that is at stake.

However, what both the Greek and the Gothic examples share is this: they present the spectator of the time with a more or less adequate material vision of their conception of themselves and of the world. For the devout medieval visitor to a cathedral the building presented an externalization of them – of their faith, of their hopes, of their deepest beliefs. So that in encountering the building they met something that seemed to be wholly at one with them. It was, realized in stone, their spiritual home.

When we come to the modern world the distance between our key concerns and the resources of art to embody these is even greater. Take, for example, the role of government bonds (just coming into use during the Napoleonic wars) in the function of the modern state. Or consider the theory of quantum mechanics as a crucial feature of the account of the physical world. Obviously, such abstract items can be referred to in works of art. But it seems absurd to suppose that a work of art could ever be the prime way of presenting these theories, that the resources of artistry would be the primary requirement for conveying these ideas and making them intelligible. Sensuous presentation doesn't enhance our understanding of these issues. It might allow for a soft version to be made more enticing to people who lack

the inclination for a full engagement with the topics. Art might provide a congenial point of entry, and we might consider this a valuable contribution to culture, but full understanding has to be pursued in a different way: by reading textbooks and academic articles. With respect to many of the most powerful ways of thinking about the world and ourselves, art isn't (and can't be) at the forefront of understanding.

Hegel's doubts about the progressive inadequacy of art to embody our self-conception (couched in the doctrine of 'the end of art') are impressive. But, of course, even if art can no longer attain this absolutely exalted status, as the primary vehicle of self-understanding, it may still be able to make an important contribution to culture and to individual life. For even if we have some major concerns which are inaccessible to art we also have major concerns which are not. Even though we live in a world of stock markets and vastly complex scientific theories, we remain perceiving, desiring beings. Thus, for example, we might think that Impressionism was an important revelation about certain kinds of enjoyment and contemplative looking, an embodiment of important attitudes and emotions, even though it was unable to convey anything very sophisticated about the science or economics of the day. This is one of the important reasons why our interest in the art of the past is not exclusively antiquarian, and why there is a certain mistake involved in insisting that art must be of its time, since many of our concerns are in no way exclusive to our time.

Think, in this respect, of Georgian and Regency town planning. The squares and crescents of Bath (plate 31) reflected an ideal of domestic and social existence. In walking through these streets the sympathetic stroller of the day would see the perfect setting (or at least a very fine setting) for their own way of life.

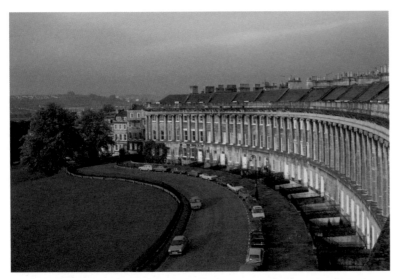

31. The Royal Crescent, Bath, eighteenth century. Such a street expresses a way of life which is still appealing today. If we share this sensibility, we feel at home here.

They would feel, we can imagine, that these streets constituted a world in which they could be at home. And, of course, we can take this seriously even though we might be persuaded by Hegel to accept that by the late eighteenth and early nineteenth centuries art no longer had the resources to compellingly represent the deepest understanding of the day. In other words, art and architecture could be doing something important, something to which Hegel's analysis draws our attention, even though it is not carrying out what he imagined to be the highest vocation of art: a vocation which, we might be very glad to reflect, never tempted the architects of The Royal Crescent. And although, of course, science, religion, politics and philosophy have all changed since then, we may still be attracted to certain aspects of the vision of life which the buildings make concrete. Whatever our science we

may still prefer spacious, geometrically simple rooms. We may still be strongly attracted to symmetry, to the lucid proportions of windows, and of the ratio of the height of building to the width of the street. Buildings which exhibit these characteristics, in the way the houses of The Royal Crescent do in Bath, still seem to capture a valid vision of existence, at least in some respects.

It should also be recalled, as a way of reducing the impact of Hegel's pessimistic thesis, that, even in the past, hardly any works of art actually did succeed in directly manifesting the deepest understanding of their day. Most works of art were less ambitious than that. Clearly, the hold a work has on our affections is not directly related to the degree to which it addresses the fundamental issues of existence. We don't need, and certainly don't want, always to be at the highest pitch of endeavour. The legacy of Hegel's thought on art is, surprisingly for one of the most grandiose of all thinkers, modesty.

In what follows I want to look in detail at ways in which buildings and paintings can answer to some aspects of our self-conception and make the world our home even though they are only doing so in relation to certain limited, but nevertheless important, concerns.

The parlour of the Eskhärad house at Skansen, Sweden (plate 32), does not look, by contemporary standards, particularly comfortable: the room lacks the smooth softness of luxury. But it may offer comfort of another, less immediately physical, kind. We get an impression not just of simplicity and calm (as well as a certain grace: the fine windows, the elegant chairs), but also an intimation of a surrounding human fabric.

Sir Ernst Gombrich once pointed out how the eye will 'fill in' gaps in a sketch. When we see a rapidly drawn line which

indicates the lift of a shoulder and the poise of an elbow, but passes over the upper arm without any indication, we do not see this as a picture of someone whose upper arm has mysteriously vanished; on the contrary, we imaginatively supply the missing limb. We do not see the *Draped Nude* by Matisse (plate 33), for instance, as a naturalistic picture of a terribly deformed woman. Although the ends of the fingers of her left hand have not been closed, imaginatively their completion is allowed for – we see the suggestion of them.

There is a broader, more social, version of this phenomenon which occurs when we build on a suggestive fragment and fill in a human context. The Matisse example suggests that this imaginative extension is not a matter of concrete visualization. It would be incorrect to say that by filling in the finger tips we visualize their actual appearance. It is rather that they are present in thought, even as we concentrate on the gaps. So, too, a way of life can be present in thought when we contemplate the view into the room at Skansen.

But what form might this elaboration take? One way is to imagine quite specifically the comings and goings of family life, to imagine that in a moment the tranquillity of the scene will be exchanged for the clattering arrival of a big family and the bustling preparation for lunch, with children chasing each other and banging doors. Or we might dream up a meditative occupant pacing the rooms, sensitive perhaps to memories which accumulate around each object, a thoughtful state of mind which finds reflection in the subdued colouring, the limpid space and the well-worn feel of materials. We might think of the age of the house, and on the succession of lives which have inhabited it.

These elaborations of thought create an aura around an image. And one way in which this building can make a deep impression

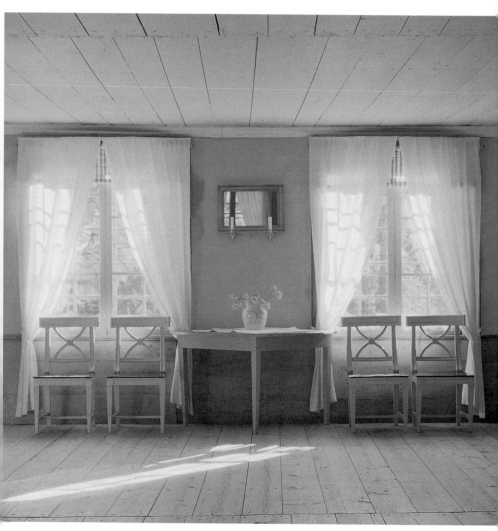

32. View into the parlour of a Swedish house. Not just a room, a vision of happiness.

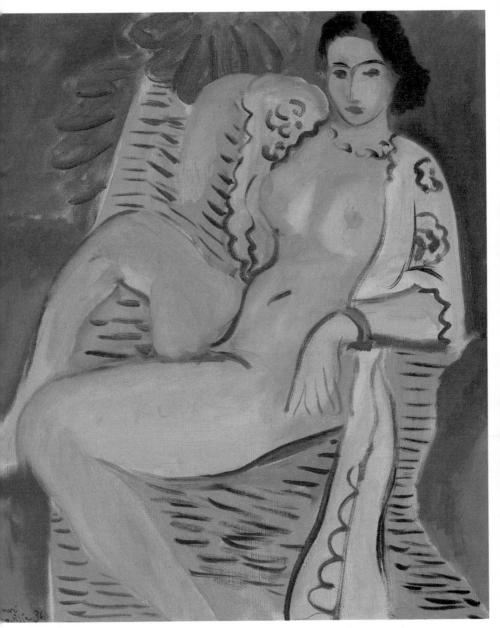

33. Matisse, *Draped Nude*. The power of suggestion: the hands are barely indicated, but we don't see her as having bananas instead of fingers.

is through its evocation of such an aura. The actual material setting gives rise to a whole emotional world; we are able (in proportion to our imaginative fecundity) to find a great deal in it. It is possible to find the world in a grain of sand – meaning that if our powers of imaginative extension are vastly productive, we can discover in so apparently unpromising an object as a grain of sand the starting point for the creation in thought of a whole world. We might view it as a tiny cosmos in its own right, or link it to the pounding of the waves which created it and find in it a symbol of the power of the sea and the mutability of rock. We might see it as a metaphor for the human condition (but every man is like a grain of sand upon the beach of life, etc.).

A grain of sand is a minimal starting point – it gives few guidelines for the world we see in it. But it does make the salient point that it is not only the object of attention, but the kind of attention we give, which is the core of finding ourselves at home in the world. The rooms at Skansen come to us with much more detailed suggestions of life. There is, for example, a contrast between the plainness of the bare boards and sophistication of the chairs; between the minimal cornice and the generosity of the windows with their attractive astragals. This contrast is suggestive of a particular emotional attitude which relishes these contrasts. The savour of a rich detail is sometimes best appreciated in a plain setting; fine things are, as it were, pockets of sharp attention in a serene atmosphere. One can feel at home, then, not just in the actual room, but also in the way of life which it suggests – but the latter requires imagination.

The idea of feeling at home, or feeling comfortable, has natural application to domestic architecture, where one might literally feel comfortably at home. But the idea has extension to a less

concrete sense of our emotional, or spiritual, home and comfort.

If Corot's *The Woman in Blue* (plate 34) makes a special impression, it might be because in contemplating the picture the spectator seems to find a part of themselves. Notice the reflective hesitancy and melancholy of the young woman; her lovely dress is a token of outward charm, but she is absorbed in her own thoughts. Corot's approach is tender. He doesn't pry into her thoughts. He is quietly alongside, a tactful presence. The picture consents to privacy.

In looking at the picture our own potential insecurities are teased forward and held in a reassuring, understanding regard. The pleasure taken in the picture goes deep because it touches upon a deep aspect of the spectator – an aspect which is usually kept out of sight. A part of human nature finds itself in the picture. It may be that it is giving form to sentiments which had, as they lay dormant, remained in an inchoate state.

This is precisely the strength of the real artist, according to Collingwood. In *The Principles of Art*, published in 1936, he extols the (true) artist's capacity to work with 'a perturbation whose nature remains elusive' (a 'hopeless and oppressed condition') and to express it – to bring the emotion fully to consciousness and to clarify its individual nature and its peculiarities. This clarification of the emotion is linked with a species of consolation: we no longer suffer in the dark (and it is a peculiar law of the heart that unknown feelings exercise a more paralysing grip upon the mind than those which are understood).

It is a curious thought that we are not particularly good at knowing our native terrain. It is easy to say who we are in terms of country of origin, post code, marital status; harder when it comes to more intimate characteristics. There are more subtle aspects of

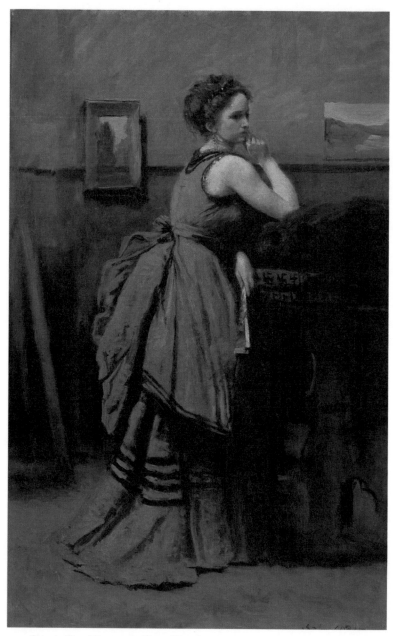

34. Corot, *The Woman in Blue*. We are close, but not intruding. Tactful sympathy realized in paint.

who we are as individuals which resist easy statement precisely because they are themselves vague and not fully formed.

The analogy with home and comfort arises from the sense of well-being which the body enjoys in favourable circumstances (lying in bed, being stroked). The relaxation and security felt in a physical way is suggestive of something more elusive (because more complex) which we can seek for the whole range of our faculties. There is, as it were, an analogous relaxation and security of spirit which we find when we feel at home with a work of art.

The notion of home suggests familiarity, but with art it is sometimes precisely in what is not at first familiar that we have the surprise of finding ourselves most at home – a dual aspect when something is, uncannily, both strange and familiar. In *Little Gidding* T. S. Eliot suggests that this quality of the strange-- familiar is a key feature of the human condition.

> We shall not cease from exploration
> And the end of all our exploring
> Will be to arrive where we started
> And know the place for the first time.

Certain experiences are moving precisely because they return us with great clarity to an aspect of ourselves which we seem to have forgotten or even betrayed. Thus they often bring a sense of loss, as we realize what it is we have lost hold of or abandoned. It is perhaps this painful aspect of intimate experience that can sometimes make us hold back and not let ourselves enter fully into a work of art which may arouse such an ambivalent revelation.

The works we have just been considering – a Swedish interior and a psychological study – lend themselves to the idea of home,

with its overtones of privacy, intimacy and domestic scale. But Hegel's suggestion can be put to work in initially less promising cases.

Claude's heroic landscape, *Landscape with David at the Cave of Adullam* (plate 35) is the sort of picture which might at first glance strike a spectator as 'un-homely'. It is lavish and grand and could hardly fit through the front door; it concerns a remote and complicated subject. King David, leading his troops against the enemy – the Philistines – in the vicinity of Bethlehem, runs low on water supplies. Some brave soldiers bring him water from the spring at Bethlehem in a helmet (which we see on the far right of the picture). David refuses the water because the spring is in enemy territory. The picture thus contains references to Christ who will be born in Bethlehem and be a living spring; and also perhaps to the then long-standing occupation of the Holy Land by the Turks. This seems to repel rather than solicit an intimate relation. But a second and longer look might lead to a different reaction.

Claude specialized in the portrayal of distance; there is hardly a major picture by him which does not include a far-reaching vista. In the painting of these pictures Claude became a master of many techniques for giving us not just an idea of distance, but a charged visual experience. What does Claude do to lend weight to it and to guide our gazing into the luminous vista?

The eye has a tendency to get used to things. The room which seemed so spacious when you moved in will seem ordinary after a few days; when you live in New York you stop thinking that the buildings are high and are surprised by how low they are everywhere else. The view from the aeroplane, which would have shaken Homer or Dante to the core, becomes jejune to the frequent flyer: another boring tract of Holland, the Dolomites

again. A painter who works on great horizons has to take steps to prevent the eye becoming jaded and keep alive the thrill of traversing such expanses in a single swoop. This problem would be intensified for a painter like Claude who was producing work which had to bear repeated attention from discriminating patrons; they would look again and again at his pictures, they wanted a picture whose impact would not diminish with the years.

One of Claude's techniques is rationing. The exquisite distance is restricted to rather less than half the width of the canvas (although it makes a fugitive appearance at other points): it is in full bloom only about one-third of the width of the picture. Another favourite Claude device is to place a comparatively near object in such a way that we see the distance against it. The pair of trees just left of centre hold themselves above the spread of the plain and we see the swathes of colour which mark each receding step inching up the canvas along the edge of the trunks (plate 36). Two kinds of distance are brought into intimate contact. The eye moves a tiny distance up the canvas, a distance which represents a few feet of bark. At the same time, our imaginative attention has traversed miles of depicted hills and valleys rolling away to a distant sea.

We cannot comprehend the whole picture at once. If we stand far back enough to take in with ease the sweep of the panorama, we will be unable to see many of the small figures who walk into the distance and many of the details out of which the gradual unfolding of the plain is constituted. If we move in close enough to see the smallest figure, then we cannot see the whole picture, indeed our vision is so restricted that we cannot see some of the details in other parts of the picture. As we move in, the picture boundaries become greater than the breadth of our vision, so that

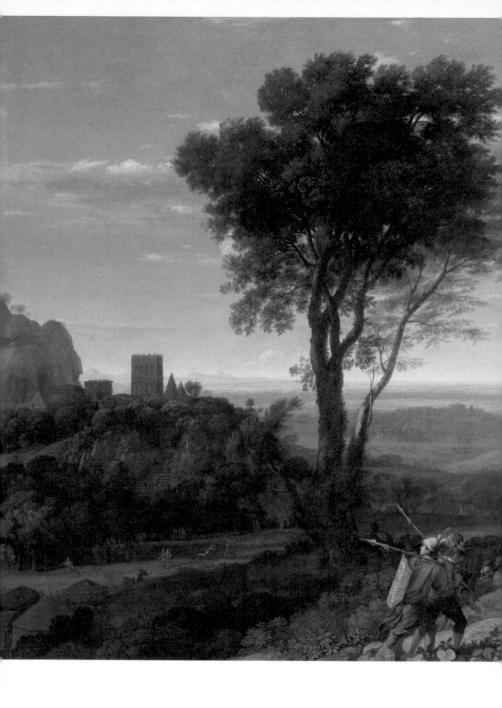

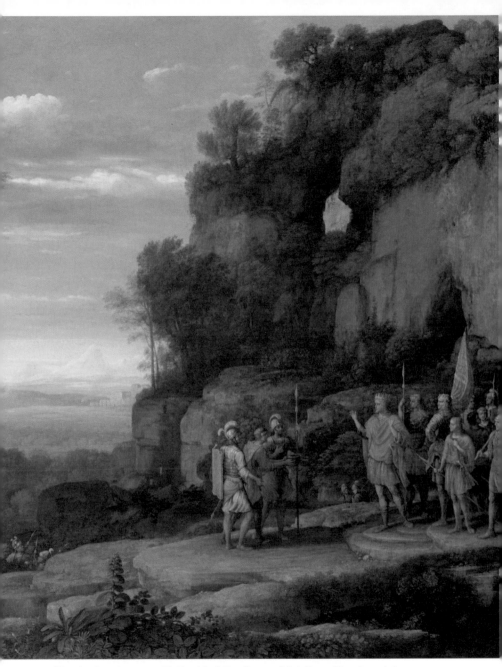

35. Claude, *Landscape with David at the Cave of Adullam*. Claude paints rocks as if he enjoyed clambering over them. The grandeur of the picture may close our eyes to its simpler charms.

we are completely absorbed – visually – within the picture whose edges extend beyond our reach.

The unfolding of distance is controlled not only by the many figures who lead the eye down to a greater and greater effervescence of detail; it is also controlled by many transitions of line. The distance does not extend smoothly but in a series of rills, of which we see the leading edges. This creates, in accordance with nature, a series of horizons, one rising above the other, and this is particularly suited to the layering of bands of colour. Within the general transition of colour – from the green of wooded hills to the blue of the sea and the white of the sky meeting the distant mountains – there is an ochre-yellow band inviting us to imagine what it is like over there and to experience – in distinction from the alarms of the foreground – the persistence of peace in the distance. In the painting, the landscape has absorbed human significance – we do not just have a distant prospect, but a prospect shaped by and accommodating human interest.

In his treatment of rock Claude paints with the knowledge of one who has enjoyed clambering, exploring fissures, stepping from one level to another. The vegetation is lush with the potentials of odour; the sky is spacious, for the eye which likes to plane and cruise among the clouds. It is a landscape painted with, painted out of, an intimate enjoyment and interest in the natural world – the natural world as habitat, not just in the limited sense of somewhere to find food and shelter, but also a place to live broadly: full of interest, sweetness, complexity and vastly big, generously and easily containing us.

Kant, Schiller and Hegel, in their treatment of art, have this in common: they think that the enjoyment of art is a central element of life. The general accounts they give of human nature all support the claim that we have a need for art. Art, in this view, is not

merely a pleasant diversion but, on the contrary, addresses and seeks to satisfy basic human concerns. Kant draws attention to the need we have to see signs of intelligent and benign purpose; Schiller to the need to find images of the reconciliation of divergent aspects of ourselves; Hegel pin-points a need to create for ourselves a spiritual home in a world which can all too easily seem indifferent to individual life. On the one hand their larger systems of philosophical explanation seek to show why it is that recognizing purpose, enjoying reconciliation or making a spiritual home are central concerns of life. They seek to show precisely how it is that these concerns are taken up in – and are integral to – the creation and enjoyment of works of art. It is non-accidental, they argue, that human cultures have devoted such energies and resources to the creation of things that we call works of art.

Fortunately, it is not necessary to be convinced of their entire philosophical systems in order to find some of their strategies and conclusions appealing (indeed to be simultaneously convinced by all three would require spectacular, and desperate, mental contortions).

The aspect of their work which I wish to emphasize here is the attention lavished upon the private engagement with works of art. The account they give of art's importance is focused upon what engaging with works of art can do for the individual spectator. But, and this is a key move, they consider what art can do for the more general needs we have as individuals – needs generated by fairly general conditions of existence. Taking inspiration from this strategy, we can continue this intellectual tradition by seeking to identify, in current terms, aspects of the human condition which feed our interest in art.

Life desensitizes us. In general, to survive we have to reduce

our sensitivity to the stimulation we receive. We have to reduce our awareness – too much goes on for us to attend to it all – we need to filter out background noise, avoid being distracted by things we catch out of the corner of an eye. Add to this the dulling effect of habit – again a necessity for ordinary functioning – by which we cease to pay much attention to the things which regularly happen and on the occurrence of which we can count. Driving along a country road we shouldn't spare too much attention for the clouds and the afternoon light slanting on the tree trunks; or getting on with the domestic chores means we probably don't have much time to contemplate the shape and texture of an apple; we so naturally expect to pass through doorways that we rarely attend to their form, their placing and individual character.

The fact that a painting or a work of fine architecture may make a special show of such ordinary elements of life can help return our attention to them. The general prestige of art invites us to approach its objects with a more alert eye; and the skill and imagination with which elements are presented can help to bring out their potential as objects of interest and charm. It is not merely in the specific trickle-back into life that we get the benefit – the new eye with which we might study an apple after a Cézanne exhibition or the attentiveness to the placing of doors, windows and the overall proportions of rooms which might follow a trip to a Palladian building – it is not only in these enhanced sensitivities back in daily life that we get the benefit of art. This one-to-one pairing – an apple in a picture, an apple on my plate – misses the way in which the stimulus to a faculty can have diverse effects; not only apples, any humble object lying about can be the focus for a Cézanne-like gaze. Not just doors, but any feature of our built environment which we have come to

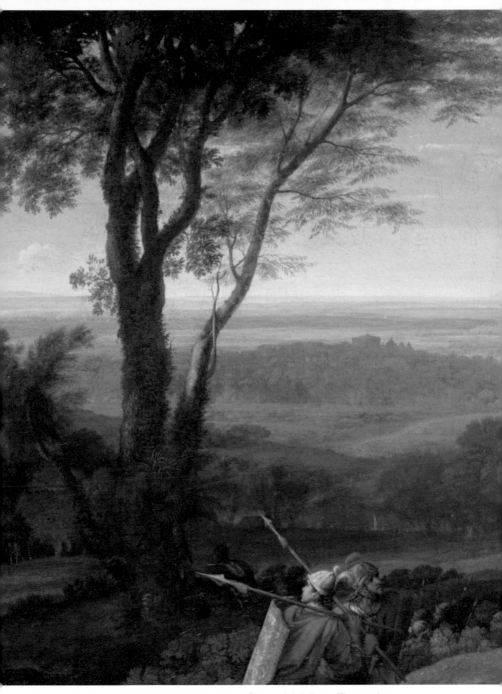

36. Detail of *Landscape with David at the Cave of Adullam*. The perfect juxtaposition of near and far. As our eyes inch their way up the tree, we are covering miles of distant hills.

take for granted can be seen with a new curiosity as to how it fits in with other elements, how it soothes or irritates the eye, how it accommodates or offends human proportions. Our faculty of sensitive response, stimulated by engagement with works of art, is limited in the objects of its attention only by the current boundaries of our imagination.

It can be hard to identify how we feel. The following is Whistler's own account (given in *The Gentle Art of Making Enemies*) of a courtroom exchange which took place when he was being cross-examined by the Attorney-General in the libel case Whistler brought against Ruskin in 1878. The specific picture in question is the *Nocturne in Blue and Gold,* but it was really a whole style of painting – exemplified as such in the Battersea Bridge painting (plate 37) which was at the heart of the trial.

A-G Now, Mr Whistler. Can you tell me how long it took you to knock off that nocturne?

W I beg your pardon? (*Laughter.*)

A-G Oh! I am afraid that I am using a term that applies rather perhaps to my own work. I should have said, 'How long did it take you to paint that picture?'

W Oh, no! Permit me, I am too greatly flattered to think that you apply, to work of mine, any term that you are in the habit of using with reference to your own. Let us say then how long did it take to – 'knock off', I think that is it – to knock off that nocturne; well, as well as I remember, about a day.

A-G Only a day?

W Well, I won't be quite positive; I may have still put a few more touches to it the next day if the painting were not dry. I had better say then, that I was two days at work on it.

A-G Oh, two days! The labour of two days, then, is that for which you ask 200 guineas!

W No – I ask it for the knowledge of a lifetime.

(*Applause.*)

But what might it be that has taken Whistler a lifetime to learn, and which he claims is encapsulated in the picture? As the Attorney-General pointed out, Whistler's work didn't seem to demand much technical competence and could quite easily be carried out in a short time. So what is the lifetime's knowledge – if we are to take the defence sympathetically – to which the artist refers?

Whistler had to detach himself from the influence of Courbet – an influence which, while it lasted, made inaccessible the moods and sentiments which were most fully his own. The discovery of a style which reflected his own individual temper was the work of a lifetime. But, of course, when we encounter the fruit of that lifetime's labour, we are presented with a distillation of that long process, so that it is made available to us in a single concentrated dose.

'No one', it is sometimes claimed, 'had seen the fog on the Thames before Whistler painted it.' Of course, that is false. But it is perhaps truer if we expand 'see' to 'see as redolent of a particular mood and hence worthy of prolonged contemplation'. Paintings are still – it is so obvious a fact as to be almost embarrassing in the statement. But it means that the painter is often in effect saying, 'Look for quite a long time at the sort of scene upon which you would only turn a passing glance.' People had doubtless, necessarily, seen the fog on the Thames in the 'passing glance' sense of seeing – all that is needed for ordinary purposes. But to regard the river fog in this way is to pick out from the

composite of general experience just this aspect to concentrate upon. Because, normally, one would not see fog on its own as the principal focus of one's visual concern, but always in conjunction with lots of other concerns; fog getting in the way of seeing the other side of the river, fog as making the river dangerous to barges, the cold weather as well as the panoply of daily thoughts which compete for attention.

It was thus a slowly won achievement on Whistler's part to focus attention on the fog and its smoky, soft effects and to connect that perception with a mood. It was difficult to arrive at this focus because the prevailing manner of looking at things – a manner he found in Courbet – was much taken with solidity, body, characteristic detail and, at times, a relish for the gritty aspects of reality. Whistler had to unlearn these perceptual manners before he could develop his own, native perceptual style and give himself over to the objects which most nearly corresponded to his private moods. The knowledge of a lifetime is, thus, not simply – not even primarily – the acquisition of technical skill with the instruments of painting; it is the development of a sense of what the painter wants to do with paint – what moods to seize, what objects to approach and in what manner. The 'Nocturnes' were not, perhaps, especially demanding from a technical point of view; but to recognize that such a way of painting answers to something deep in oneself is a major achievement.

The spectator's sense of this achievement is liable to be dulled because the painting does not bear the marks of apparent struggle. All Whistler's artistic battle to get away from Courbet and to develop his own style are off-stage, and the viewer is presented only with a smooth, accomplished final statement. It is a measure of Whistler's success in identifying a mood and a suitable object for that mood that the picture now looks natural –

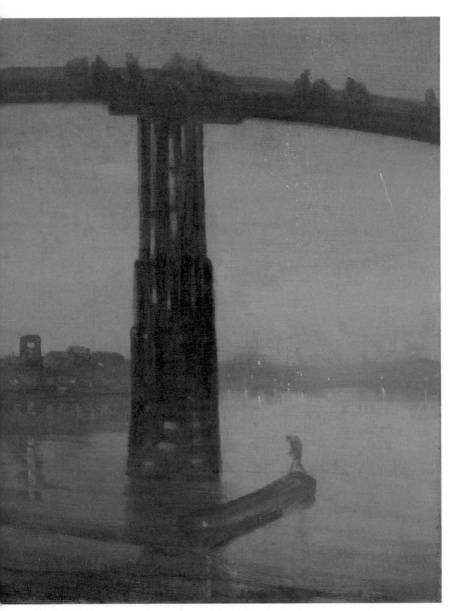

37. Whistler, *Nocturne in Blue and Gold: Old Battersea Bridge*. Whistler insisted that painting this picture required 'the knowledge of a lifetime'. What did it take him so long to find out?

the difficulty we have is in imagining how anyone could not have seen things this way. And conversely, this indicates how difficult it is to come up with, on one's own, an identification of the kind of mood Whistler manages to make clear, so that we most easily identify it by reference to the painter. And from the dispersed, disordered jumble of experiences which constitute a winter walk by a river or an urban night emerges cleanly and clearly a Whistlerian episode.

The discussion of Whistler provides a case study of a general artistic phenomenon. If Vermeer or Claude had been the focus of inquiry, we would have picked up on the discernment and pictorial elaboration of quite different perceptions and responses. This goes some way towards explaining why individual pictures or painters sometimes have a particularly strong appeal for certain spectators. The sensibility of the artists – the quality of experience they isolate and dwell upon – strikes a chord with certain gallery visitors. Given our differing temperaments, this is inevitable. But it also suggests that it may be a false goal to try to appreciate all great works of art with equal devotion, some works just will treat experiences closer to one's heart than others.

To draw attention to the private use we make of works of art is not to deny that pictures and buildings also have an impersonal role (as complex documents about the past, as merchandise with a market value). But it is to suggest that we would misapprehend works of art if we did not consider them in this private way. Adopting such an intimate and personal point of view is not a retreat from the work, not a flight into a subjective realm which ignores the real significance of the work; on the contrary, adopting such a stance is central to recognizing some of the most important aspects a work of art can have. Private use is not a sly substitute for, but an essential feature of, the appreciation of art.

The emphasis on private use also helps illuminate the human position of art. For each of these uses connects an area in which life is often problematic to a cultural resource for coping with that problem. Because the problems identified are deep set in the human condition, it is unsurprising if the appeal of art and what it can characteristically offer is equally deep set. But – and this is the crux of the matter – unlocking the resources of art requires that we approach individual works in a particular spirit: the spirit of intimate and personal engagement.

The general task of this book has been to elaborate the style of attention which works of art solicit. The cultivation of such a style is of importance because it is in the quality of our engagement that the human worth of art is apparent – art matters in virtue of the kind of experience it invites the spectator into. There is no access to art except in private – in looking, thinking, feeling as we stand before an individual work. Cultivation requires that we draw upon our own resources of sensitivity, reverie and contemplation, our capacity to invest our ideals and interests in the process of looking. Without these we can only know about art as detached observers who look on without being able to participate (like seeing people share a joke others don't quite catch).

There are various obstacles to the appreciation of art. Some are only too obvious and external: lack of leisure, competing interests. There are also more subtle internal hindrances – 'enemies of promise' – which become apparent when the external obstacles are removed, when we step expectantly into the gallery, in a holiday mood: plenty of time before lunch, nothing to do except have an enjoyable and interesting time. These are the problems of misleading expectations, of shyness (as it were) before acclaimed works, doubts about what we are supposed to be looking at, submission to the guidebook. The way out of these

difficulties – the argument has run – is to cultivate one's own response.

In his charming essay *An Apology for Idlers* Robert Louis Stevenson felt he had to counter an embarrassing objection to his defence of taking things easy. He was himself a hard worker. And he could hardly be unaware of the incredibly obvious spurs to, and rewards for, healthy effort. 'It is certain,' he admits,

that much may be judiciously argued in favour of diligence; only there is something to be said against it, and that is what, on the present occasion, I have to say. To state one's argument is not necessarily to be deaf to all others, and that a man has written a book of travels in Montenegro, is no reason why he should never have been to Richmond.

He might have further pointed out that diligence needs no defence, it already holds the day. With art, the need for sound historical knowledge – and the industry of examining what art reveals about the people who made and bought it – holds today. This is orthodoxy; much can judiciously be argued in favour of it.

Only there is something to be said against it: this diligence towards art tends to ignore the roots of attachment to and delight in art. It may be, for instance, that a painting by Manet (to take one of countless possible examples) is a social document about the pernicious attitude of men towards women, as one art-historian has claimed of his *Masked Ball at the Opera*; yet no one ever loved a social document. If, indeed, it is a social document, it must also be a great deal more than that; and it is these further things which stand in current need of apology.